D1415635

The Art of West African Kingdoms

Project Director
Edward Lifschitz, *Curator*
Department of Education and Research

Published for the National Museum of African Art
by the Smithsonian Institution Press

Washington, D.C., and London

This publication made possible with a grant
from the Shell Companies Foundation, Inc.

Acknowledgments
We are indebted to the Shell Companies Foundation for its generous grants to
create the museum programs that led to the ideas for this project and for its
support of the writing and production of this book.

Anita Mintz wrote the first draft of the book. Sylvia Williams, Roy
Sieber, Bryna Fryer, and Margaret Bertin read various drafts as the project
proceeded. The book was edited by Dean Trackman and designed by
Christopher Jones. Janet Stanley, the chief librarian of the National Museum
of African Art, provided valuable research assistance and contributed
annotations for the bibliography. Special thanks go to Judith Luskey, the
museum's photo archivist, who served as picture editor and researched,
sought, and prepared photographs for the book. Kim Rich put together the
glossary, bibliography, and chronological table, Jon Reel handled the orders
for the photographs, and David Harper typed the numerous drafts.

E.L.

Library of Congress Cataloging-in-Publication Data
The art of West African kingdoms.

Bibliography: p.
1. Art, Black—Africa, West—Themes, motives.
2. Art, Primitive—Africa, West—Themes, motives.
I. Lifschitz, Edward, 1945- .
II. National Museum of African Art (U.S.).
N7398.A75 1987 709'.01'10966 87-11332
ISBN 0-87474-611-6

Cover photo: Brass figurative sculpture, Ife, Nigeria
(fig. 30 in text)

Photo Acknowledgments
The National Museum of African Art gratefully acknowledges the following for
permission to use the photographs reproduced in this book. Basel Mission Archives: fig.
11; Detroit Institute of Arts, Founders Society: figs. 26, 27, 29, 31, 32, 34, 45; Eliot
Elisofon Archives, National Museum of African Art: figs. 2, 4, 5, 8, 9, 10, 12, 13, 14,
15, 16, 17, 18, 20, 21, 24, 25, 28, 30, 35, 37, 38, 40, 41, 43, 49; Equinox (Oxford
Limited): fig. 33; William B. Fagg: figs. 36, 46; Hirshhorn Museum and Sculpture
Garden: figs. 42, 44; Indiana University Art Museum: fig. 3; Metropolitan Museum of
Art: fig. 47; Musée de l'Homme: fig. 19; Musée des Arts Africains et Océaniens: 23;
National Anthropological Archives, Smithsonian Institution: 6; Seattle Art Museum,
Katherine White Collection: fig. 39.

Contents

Preface

In 1984, the National Museum of African Art, with a grant from the Shell Companies Foundation, began a pilot educational outreach program in the schools of Washington, D.C. In its first year, the program, "Art the Communicator," presented a series of sessions between a museum educator and fourth- and fifth-grade students from one District of Columbia school. The sessions, which took place in the classroom, reviewed the basic elements of perception and the universality of art. The students discussed how artists, using such elements as color, line, texture, volume, space, and size, convey ideas, feelings, and experiences in their art. They explored symbolism in art and began to understand that full comprehension of a work requires knowledge about the artist's culture. The program culminated with a tour of the museum and participation in a hands-on art workshop.

The following year the program was expanded to include the fourth, fifth, and sixth grades of another District of Columbia school. The program's technical features were improved, and with encouragement from teachers, plans were made for further expansion of the program by training museum volunteers to conduct the classroom lessons.

Significantly, the on-site program revealed the absence in the elementary schools of in-depth exposure to African art and culture, as well as to museum programs in general. In addition, it made the museum staff aware that teachers and students need publications that provide a basic understanding of African art. Thus, with a generous gift from the Shell Companies Foundation, the museum's Department of Education and Research publishes this initial volume illuminating the diversity of African art and culture.

The Art of West African Kingdoms is written for teachers at the upper-elementary and secondary levels. It focuses on a selection of the major kingdoms in order to trace West African art history from the tenth century to the present. Each kingdom's primary art forms are discussed in conjunction with its culture. Also included are a chronological table, maps, a glossary, an annotated bibliography, and four educational posters for the teacher who wishes to incorporate the subject into a curriculum.

The museum's staff will continue to develop local educational outreach programs. At the same time, it hopes that this book is the first of many specially developed educational publications designed to serve a national audience.

Art History and Learning to See

One of the most exciting ways to learn about the history and beliefs of a people is by exploring their visual traditions. The discipline that addresses this area of study, and the catalyst for this book, is called *art history*.

The visual arts are among the ways people communicate with one another. Works of art are part of a culture; their symbolism expresses deeply held values and beliefs. Looking at an object for the first time, however, a person outside the culture may see it only as a perplexing and silent image. To understand the artwork and those whose hands and thoughts created it, the art historian seeks to unlock its history and meanings. Exploration of the visual arts is an analytical visual process, a process of "learning to see" what is before the eyes.

A number of fundamental questions arise when one looks at an unfamiliar work of art. What is it? What does it mean? Why does it look the way it does? Where did it come from? Who made it? Why was it made? What materials were used? Is it old? How is it similar to or different from other objects that are more familiar? The queries of the curious observer are also the queries of the art historian. Answering them—learning to see—may begin with a description of an object, analyzing its compositional elements, such as line, volume, space, color, and texture. In the case of African art, learning to see also means trying to reach an understanding of the values and beliefs that inspired the artist to create the image. As more information becomes known, history, culture, and meaning unfold.

Understanding the cultural uses of an object likewise helps to explain its imagery and heighten its aesthetic appeal. African art displayed in a museum setting or illustrated in a book is not seen or used as it would be in Africa. There, as in most traditional societies, art plays a daily role in people's lives. Africans create their art to serve specific uses. African art is pottery for carrying water; it is textiles, leatherwork, and jewelry for wearing; it is sculpture for use in ceremonies and rituals. An African object viewed in isolation, compelling as it may be, loses some of its meaning and visual impact. An African mask, for example, is worn as part of an entire costume that covers the wearer from head to foot. The wearer of the mask participates in a performance that could include music, dance, song, and storytelling.

A complete art history of the peoples and cultures of sub-Saharan Africa has not been written, and some of the history will never be known. Certain works will forever remain shrouded in mystery. The African peoples of past centuries left no written records, so their art history is reconstructed by studying what is known, such as oral traditions, European and Arabic documents, languages, and archaeological discoveries. The young discipline of African art history is now entering a dynamic stage of discovery.

With but a glimpse at the visual arts of the most famous kingdoms of West Africa, this book introduces the teacher to one approach to West African history. There is more to be gained in exploring the art, however, than a broader knowledge of African cultures and history. A deeper understanding of the vibrant African visual traditions offers a rich aesthetic experience.

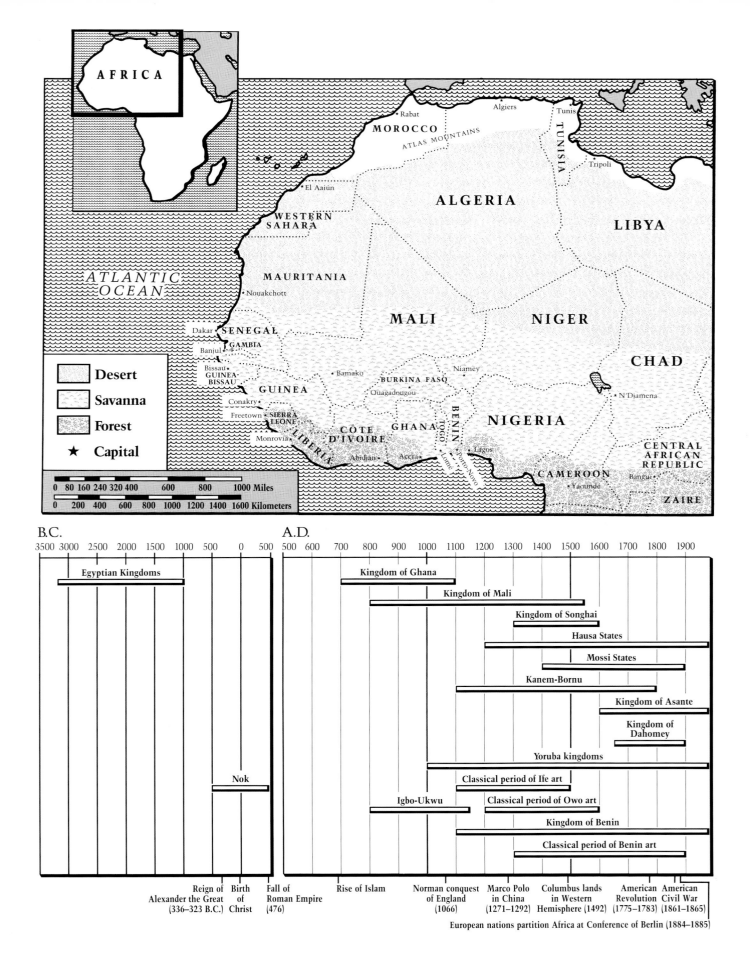

AFRICA

Desert
Savanna
Forest
★ Capital

MOROCCO
Rabat
ATLAS MOUNTAINS
Algiers
Tunis
TUNISIA
Tripoli

ATLANTIC
OCEAN

El Aaiún

WESTERN
SAHARA

ALGERIA

LIBYA

MAURITANIA

Nouakchott

MALI

NIGER

CHAD

Dakar
SENEGAL
Banjul
GAMBIA
Bissau
GUINEA-
BISSAU
GUINEA
Conakry
Freetown
SIERRA
LEONE
LIBERIA
Monrovia

Bamako

BURKINA FASO

Ouagadougou

Niamey

N'Djamena

NIGERIA

CÔTE
D'IVOIRE
Abidjan
GHANA
Accra
TOGO
BENIN
Lomé
Porto-Novo
Lagos

CENTRAL
AFRICAN
REPUBLIC
Bangui

CAMEROON
Yaoundé

ZAIRE

0 80 160 240 320 400 600 800 1000 Miles
0 200 400 600 800 1000 1200 1400 1600 Kilometers

B.C.

3500 3000 2500 2000 1500 1000 500 0 500

Egyptian Kingdoms

Nok

A.D.

500 600 700 800 900 1000 1100 1200 1300 1400 1500 1600 1700 1800 1900

Kingdom of Ghana

Kingdom of Mali

Kingdom of Songhai

Hausa States

Mossi States

Kanem-Bornu

Kingdom of Asante

Kingdom of
Dahomey

Yoruba kingdoms

Classical period of Ife art

Igbo-Ukwu

Classical period of Owo art

Kingdom of Benin

Classical period of Benin art

Reign of
Alexander the Great
(336–323 B.C.)

Birth
of
Christ

Fall of
Roman Empire
(476)

Rise of Islam

Norman conquest
of England
(1066)

Marco Polo
in China
(1271–1292)

Columbus lands
in Western
Hemisphere (1492)

American
Revolution
(1775–1783)

American
Civil War
(1861–1865)

European nations partition Africa at Conference of Berlin (1884–1885)

Introduction

BETWEEN THE TENTH AND TWENTIETH CENTURIES, vast kingdoms south of the Sahara in West Africa flourished and fell. Powerful kings built elaborate royal cities and, to proclaim their wealth, power, and divine right to rule, commanded skilled artisans to fashion works of art, often from sumptuous materials. Today, except for the hand-built earthen mosques of the Western Sudan, little of the grand architecture remains, and the people have left no written literature or historical records. Their artworks are among the few remaining links to the glories of the past kingdoms.

For nearly five thousand years, from the time of the pharaohs until the nineteenth century, the kingdoms of Africa were some of the continent's most creative societies. The Western world knows much of the Egyptian kingdoms. Egypt was a crossroads of the ancient world, and in its tombs and stone buildings there is an extensive record of the old dynasties. But of the kingdoms that were scattered throughout Africa's interior—difficult to reach and situated in climates that devastate all but the most enduring materials—much less is known.

Western societies have always been intrigued by Africa, once commonly referred to as the "dark continent." Numerous formidable obstacles impeded the ambitious foreigner wishing to penetrate Africa. The total land mass, more than three times that of the United States, is staggering. Its wide-ranging geography of deserts, mountains, grasslands, and rain forests is difficult to cross, especially in tropical heat or during seasons of heavy rainfall. Debilitating and often deadly diseases, such as sleeping sickness transmitted by the tsetse fly and mosquito-borne malaria, awaited some who ventured into Africa.

When Europeans finally reached the coastal kingdoms of West Africa in the fifteenth century, at least seven centuries after Muslim travelers and traders from North Africa began visiting the savanna kingdoms of the West African interior, they were astonished to find highly developed societies. Over time, Muslims and Europeans who traveled to the kingdoms influenced, among other things, traditional African art; African artists incorporated foreign motifs into the objects they created and adapted new materials and techniques. The accounts of these early travelers and of those who followed provide historically important information about some of the early African kingdoms.

In more recent centuries, most who journeyed to Africa were avaricious and had little desire to understand the African people and their culture. The major interest of Europeans was trade, particularly the lucrative trade in pepper, ivory, gold, and slaves. By the late

nineteenth century, except for Liberia, a republic settled by freed slaves from the United States, the entire African continent had been partitioned into colonies by various European nations.

Since the Second World War, Western historians, anthropologists, art historians, and archaeologists have traveled to Africa in growing numbers. Working with African scholars, they are learning more about Africa's past, including the political, economic, and artistic achievements of the African kingdoms.

The oldest of the known kingdoms—Ghana, Mali, and Songhai—were in the Western Sudan region, the great swath of savanna between the Sahara and the rain forests of West Africa. In medieval and Renaissance times, between the eleventh and seventeenth centuries, court life in these kingdoms was well developed. Many kings lived on a grand scale, attended by large retinues of courtiers, servants, and slaves. They presided over palace compounds that were as large as cities. The royal compounds included living quarters for wives, children, and those who guarded and served the kings. Carvers and metalsmiths, some organized into guilds, frequently had workshops in the royal cities where they created beautiful objects exclusively for the kings. The palaces, which were built of sun-dried mud brick and sometimes whitewashed and elaborately decorated, have almost all vanished. Their fragile mud construction required continual renewal; without it, even the grandest structures rapidly deteriorated.

Other kingdoms—Asante, Dahomey, the Yoruba kingdoms, and Benin—were located in the forest lands farther south toward the West African coast. Many more works of art exist from these kingdoms, but their histories are often just as fragmentary. Trade was an integral part of the kingdoms' economies, contributing to their affluence and expansion. The writings of foreign visitors shed light on the ways of life in some of the kingdoms, especially the kingdom of Benin.

The regal courts of the forest kingdoms were comparable to those of the savanna kingdoms. The kings, like their savanna brethren, exercised great authority. As in most African kingdoms, the production of certain art objects was often strictly controlled by kings; to cast brass without the king's permission in Benin, for example, could result in execution.

The sacred rulers of the savanna and forest kingdoms of West Africa were awesome figures who usually wielded absolute power. They were believed to be either deities or descended from gods. Kings commanded large armies and became wealthy by exacting tribute from neighboring peoples. Often, too, their lands were blessed with an abundance of natural resources. Some were fortunate to be situated on lucrative trade routes, collecting payments from traders who crossed their territories bearing imported luxury items either from the north across the Sahara or from ocean ports to the interior.

Most common people lived outside of the royal cities in small villages. Their closest allegiance was to a village chief. Societal bonds were strong in the village, and someone without a family—an orphan or a widow—knew that the community would take care of his or her well-being.

African life was sustained by the pulse of ritual. Infused with music, dance, and art, ritual animated the spirit world. Traditional African religions, then as now, were based on the belief that spirits dwell in natural forms, such as trees or the earth, in created objects, such as figurative carvings, and in functional objects, such as drums. Ancestors were always nearby, and attention had to be paid to them. To assure the proximity of protective spirits, families often used clay or wooden figures. Every village had its own ancestral shrine where communitywide ceremonies were performed.

Royal ritual in many ways paralleled personal and village ritual. Palaces also contained ancestral shrines, which were closely guarded by honored retainers. These shrines could be filled with wood, clay, stone, and metal sculptures. Because they were made from durable materials and stored carefully, the sculptures are the finest tangible objects—and often the only objects—remaining from the older kingdoms.

Although many of the kingdoms have disappeared, some descendants of those from the old realms, now citizens of independent nations, still create in the traditional styles. Moreover, the voices of their ancestors still speak to us across the centuries through the art that has survived. Such objects as the lifelike brass heads from Ife, the intricately carved ivory tusks from Benin, and the masterworks of gold from Asante are the legacies of the artists from the kingdoms of West Africa.

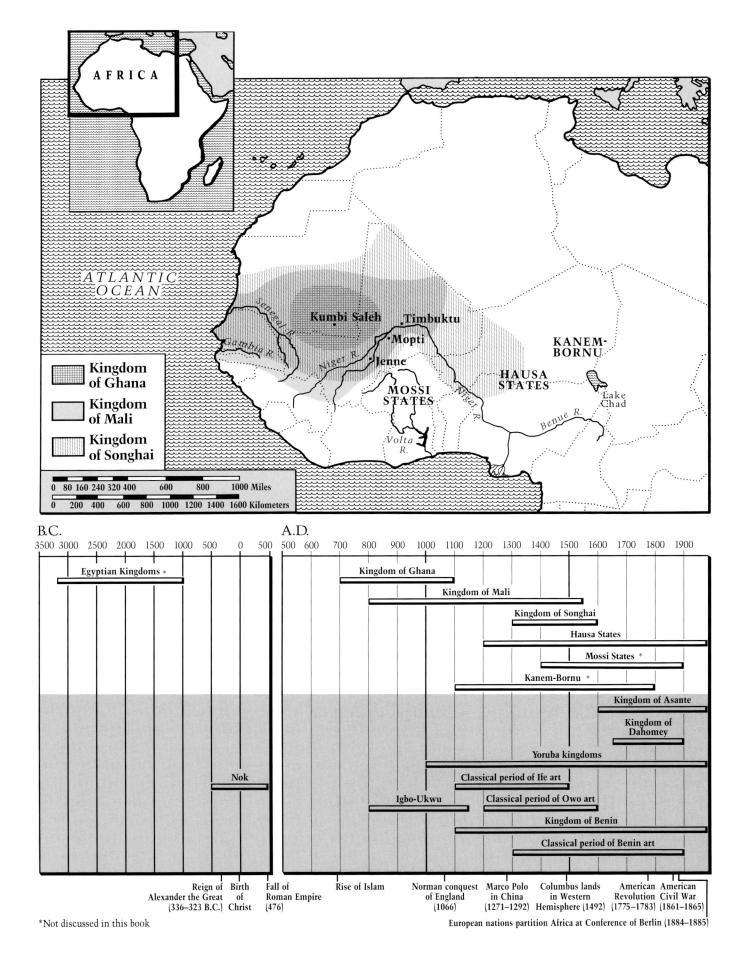

AFRICA

ATLANTIC
OCEAN

Kumbi Saleh • • Timbuktu

• Mopti

• Jenne

MOSSI
STATES

HAUSA
STATES

KANEM-
BORNU

Lake
Chad

Senegal R.

Gambia R.

Niger R.

Niger R.

Benue R.

Volta
R.

Kingdom
of Ghana

Kingdom
of Mali

Kingdom
of Songhai

| 0 | 80 | 160 | 240 | 320 | 400 | 600 | 800 | 1000 Miles |

| 0 | 200 | 400 | 600 | 800 | 1000 | 1200 | 1400 | 1600 Kilometers |

B.C.

3500 3000 2500 2000 1500 1000 500 0 500

Egyptian Kingdoms *

Nok

A.D.

500 600 700 800 900 1000 1100 1200 1300 1400 1500 1600 1700 1800 1900

Kingdom of Ghana

Kingdom of Mali

Kingdom of Songhai

Hausa States

Mossi States *

Kanem-Bornu *

Kingdom of Asante

Kingdom of
Dahomey

Yoruba kingdoms

Classical period of Ife art

Igbo-Ukwu

Classical period of Owo art

Kingdom of Benin

Classical period of Benin art

Reign of Birth Fall of
Alexander the Great of Roman Empire
(336–323 B.C.) Christ (476)

Rise of Islam

Norman conquest
of England
(1066)

Marco Polo
in China
(1271–1292)

Columbus lands
in Western
Hemisphere (1492)

American
Revolution
(1775–1783)

American
Civil War
(1861–1865)

*Not discussed in this book

European nations partition Africa at Conference of Berlin (1884–1885)

I

Kingdoms of the Western Sudan

BEFORE THE SEVENTEENTH CENTURY, three great kingdoms prospered in the wide savanna, or grasslands, south of the Sahara and north of the tropical rain forest in West Africa. The earliest of these, the kingdom of Ghana, has been lost in the mists of time. In the eighth century A.D., and perhaps centuries earlier, it was a land of fabulous wealth and pageantry, roughly encompassing what is now southern Mauritania and the Republic of Mali.*

Some of ancient Ghana's great wealth came from gold deposits in the south. But most of its prosperity resulted from its location in the midst of a lively trans-Saharan network of caravan trade routes. Caravan traders primarily carried salt, copper, and manufactured goods to the south and brought gold and slaves north. Each time goods crossed Ghana's borders, whether coming into the kingdom or going out, the king exacted a duty on the bearers.

Today, there are few traces of the kingdom beyond the ruins of its splendid capital, Kumbi (now Kumbi Saleh in Mauritania). Although the oral tradition of the Soninke people who ruled the kingdom of Ghana continues, no ancient Soninke writings, sculpture, or other art from the time of the kingdom has been found.

Controlled archaeological study has been under way in the area only since 1977. Numerous reasons explain why research was not undertaken earlier. As with many Third World areas, potential excavation sites are often overgrown with vegetation or currently inhabited by other peoples, technical facilities are scarce and communication is slow and complex, and archaeological expeditions are extremely costly. So, until now, scholars of African history have been able to draw only a fragmentary picture of the kingdom of Ghana, derived mostly from the writings of early Arab travelers and chroniclers. Sometimes these descriptions are highly colored accounts of a society in which worldly wealth lavishly embellished the stature of its sacred kings.

City of Kumbi and the Royal Court

Abdullah Abu-Ubaid al-Bakri, an eleventh-century Arab geographer whose *Book of Roads and Kingdoms* provided the first general survey of the Western Sudan region, described in detail the capital city of Kumbi and the royal court. Based on information given to him by

* The kingdom of Ghana has no geographic or known historical association with the modern West African nation of Ghana.

North African merchants who had traded there, he reported that Kumbi was really two urban areas about six miles apart. One, a city of the Muslim traders, contained houses built of stone, some of which were two stories high, and a dozen mosques. It attracted scholars and merchants from distant lands. The other area was the king's city and its surrounding settlements. The traditional-style houses were built with earthen walls and thatched roofs on wooden beams.

Recent excavations at Kumbi Saleh have unearthed stone houses similar to those al-Bakri described. Traces of narrow streets leading to a wide central avenue where the market would have been give further credence to his report. Existence of the gold trade was substantiated by the discovery of small glass weights that were probably used to measure gold.

The immense wealth of the land was reflected in the royal court. Al-Bakri told of the audiences given by King Tenkaminen in 1065. "When people approach the ruler of Ghana, they fall on their knees and sprinkle their heads with dust," al-Bakri wrote. The king, laden with gold jewelry, sat in a pavilion that was surrounded by ten horses covered with gold-trimmed trappings. Behind the throne stood ten pages bearing gold-embellished shields and swords, while hounds with collars and bells of silver and gold held guard over all.

Another writer, Mahmud al-Kati, a sixteenth-century Soninke scholar, wrote of the largesse of a king named Kanissa'ai, who lived long before al-Kati's time. Kanissa'ai would meet his people in the evening by the light of a roaring fire fueled by a thousand faggots, al-Kati reported. Seated "upon a balcony of red-gleaming gold," the king would then command his servants "to bring forth food for ten thousand people."

An Origin Myth of Ancient Ghana

The traditional myths and folktales of Africa are almost entirely oral. They convey the history, beliefs, and mores of a people. Origin myths are important in the development of African society because they provide continuity from the past to the present. Insofar as the myths are accepted and retold, they establish the origin and legitimacy of a ruling dynasty.

A traditional legend about the kingdom of Ghana, still sung by Sudanic *griots*, or bards, tells of its beginning and fall. In this legend, the founder of the kingdom, Maghan Diabe, received permission to settle on the land from the black snake Bida. He promised Bida that each year at harvesttime the most beautiful virgin would be sacrificed to him. In return, the land was to be blessed with ample rainfall and abundant crops. So it was, until one year a magician fell in love with the girl who was to be sacrificed. To save her life, he mortally wounded Bida. The infuriated dying snake used his last breath to issue a curse that Ghana would suffer desiccation and famine. Soon the fertile earth turned to desert and the people dispersed, bringing Ghana's hegemony to an end.

Myths such as this one often provided inspiration for the art that is so closely bound to spiritual beliefs and rituals. The myth of Bida has been cited to explain the prominence of the snake motif in many genres of West African art.

The Art of West African Kingdoms

A variation of the Bida myth tells how farmland close to the Niger River was regularly threatened with devastating floods. To propitiate the gods and spare houses and crops from destruction, according to the myth, virgins were regularly buried alive in building foundations. In 1977, a few small terra-cotta statues were found near the foundation of a ruined building in an area that once was part of the kingdom of Ghana. Some have speculated that over time clay figures were offered instead of young women.

A more plausible account of Ghana's demise than the Bida myth is historically documented. In 1076, following a long struggle to dominate the thriving West African market towns, the Almoravids, a Berber Muslim sect, defeated the Soninke rulers and precipitated the dissolution of the kingdom. As the Soninke departed, the land they had productively cultivated was left to the Berbers, a nomadic, pastoral people. Their livestock overgrazed the land until it became the arid tract found today.

GHANA WAS SUCCEEDED IN THE twelfth century by the kingdom of Mali, whose leaders built an empire much larger than Ghana. Before Mali's decline and fall in the sixteenth century, it was second in area only to the Mongol Empire of Asia, which at one time encompassed Asia and most of Eastern Europe. Mali's territory included the great Islamic center of Timbuktu, a city noted for its rich intellectual life, library of North African Arabic texts, and brisk book trade. Portugal and the other Mediterranean countries that traded with the empire treated Mali as an equal.

The Pilgrimage of Mansa Musa

Perhaps as a gesture of friendship and to promote trade, the early kings of Mali nominally adhered to Islam, although among their own people they retained the spiritual powers and status inherent in their believed tradition of divine origin. One king, Mansa Musa, made a spectacular pilgrimage to Mecca in 1324. According to some accounts, he was accompanied by a retinue of thousands, including five hundred slaves carrying about four pounds of gold each. On the way home he stopped in Cairo. Dispersing gold to almost everyone he met, he flooded the marketplace with currency. The resulting monetary devaluation was reported to have lasted at least twelve years.

Mansa Musa, the greatest of Malian kings, extended the dominion of the kingdom throughout West Africa (fig. 1). Mali's power and reputation as a center for learning became well known in North Africa. Returning with Mansa Musa from Egypt were architects and scholars who chose to settle in Mali, especially in Timbuktu. The mosques in the cities of Timbuktu and Jenne today, though many times repaired and rebuilt, are monuments of Western Sudanic architecture (fig. 2).

Splendor of the Court

The fabulous accounts by Arab writers, like those about Ghana, enable us to envision the splendor of Mali's court. Muhammad ibn Abdullah ibn Battuta, a Berber scholar and theologian who spent

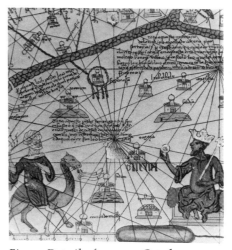

Fig. 1. Detail of a 1375 Catalan map. The map shows the principal cities of the Western Sudan and also depicts Mansa Musa, ruler of Mali, receiving an Arab merchant.

Map by Abraham Cresques, 1375

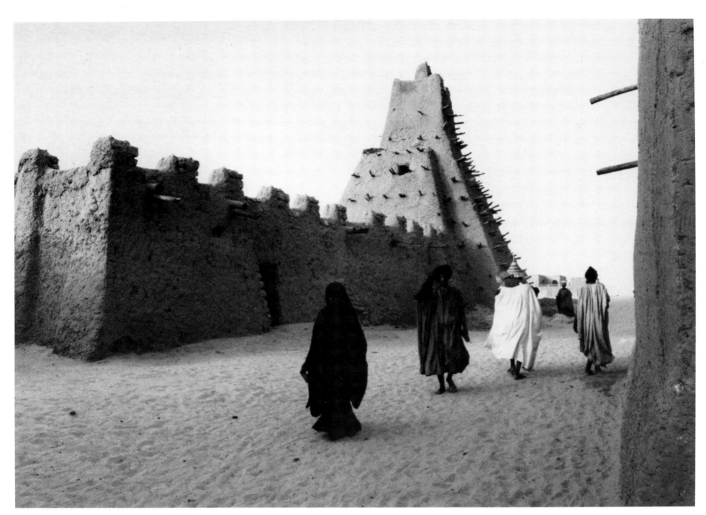

Fig. 2. Sankore mosque, Timbuktu, Mali. Wooden poles that project from the minarets and mihrabs of mosques in the Western Sudan serve as scaffolding during the annual refinishing of earthen walls.

Photograph by Eliot Elisofon, 1970

about a year in the kingdom of Mali, wrote a vivid chronicle of his travels. He did not hesitate to criticize his hosts for what he regarded as the sparsity and plainness of the food they offered him. But he was unstinting in his admiration of the magnificent spectacle of royal audiences.

The king, or as Ibn Battuta called him, the sultan, entered the palace yard wearing a golden skullcap and a velvety red tunic and carrying a bow in his hand and a quiver on his back. "The sultan is preceded by his musicians, who carry gold and silver *guimbris* [two-stringed guitars], and behind him come three hundred armed slaves," Ibn Battuta wrote. He walked slowly to a platform carpeted with silk and covered with cushions; it was shaded from the blazing sun by a large umbrella, "a sort of pavilion made of silk, surmounted by a bird fashioned in gold about the size of a falcon." On reaching the platform, the sultan "stops and looks round the assembly, then ascends it in [a] sedate manner. . . . As he takes his seat, the drums, trumpets, and bugles are sounded."

Ibn Battuta was also impressed by the kingdom's high level of civility. "Of all peoples, the Negroes are those who most abhor injustice. The sultan pardons no one who is guilty of it," he wrote.

The Art of West African Kingdoms

"One enjoys complete and general safety throughout the land. The traveler [in Mali] has no more reason than the man who stays at home to fear brigands, thieves, and ravishers." Ibn Battuta praised the Malians' honor in dealing with foreigners. They "do not confiscate the goods of any North Africans who may die in their country, not even when these consist of large treasures. On the contrary, they deposit these goods with a man of confidence . . . until those who have a right to the goods present themselves and take possession."

Terra-Cotta Sculptures

The Arab chroniclers had little to say about any clay or wood sculpture beyond references to "idols" or "ridiculous birdlike masks," but their vivid descriptions of cities and burial places have guided archaeologists, albeit with modest success, in the search for traces of vanished civilizations. Since 1940, farmers, collectors, and scholars have found a substantial number of terra-cotta sculptures, as well as a smaller quantity of brass and gold castings, in the inland Niger Delta, a floodplain between the cities of Mopti and Jenne in modern Mali. Tests of some of the discovered terra-cotta objects indicate dates of origin ranging from the ninth to the seventeenth century. (Terra-cotta objects are dated using a technique known as thermoluminescence dating, which measures the energy that has accumulated at a regular rate in the clay crystals since the time the object was fired.) No evidence has yet been discovered to link the terra-cotta sculptures with the kingdom of Mali, although many were produced during Mali's rule.

The terra-cotta statues display a range of images and themes. Some represent hunters or warriors carrying quivers on their backs, and others are of bound prisoners. There are equestrian statues, some showing the rider larger than his mount (fig. 3). Sculptures sometimes portray animals—monkeys, lizards, dogs, birds, fish, and, the commonest, snakes—either as separate objects or as motifs decorating human figures. Female statues may be adorned with depictions of beads and heavy bangles; males may have a sword tucked in a baldric, an ornamented belt worn over a shoulder and across the chest. The brass castings, fewer in number than the terra-cotta works, include human and animal figures, jewelry, and miniature masks about three inches in length.

The most striking terra-cotta statues are standing, sitting, or kneeling human figures, each with a somewhat flattened, elongated head tilted upward, stylized features, and a pointed chin. (An example of this style is seen in fig. 3.) Other figures are more cylindrical, with smaller, rounded heads and level gazes.

The purposes of these sculptures are unknown. It is possible that the equestrian works either reflected the importance of the horse or imparted status to certain chiefs. The kneeling figures may have been components of ancestral altars that were placed at the entrances of houses where sacrifices were made.

Nothing is known about the artists who created these works. We can only infer that they were members of an occupational caste and, as such, may have been officials of the court who enjoyed the confidence of the king.

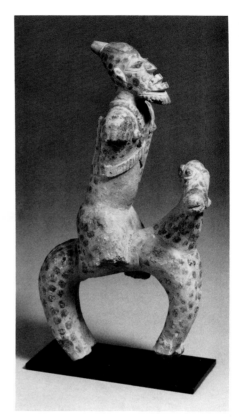

Fig. 3. Terra-cotta equestrian figure, Jenne culture, Mali. The crossed baldrics and beard of this male figure astride a horse, dated between the fifteenth and eighteenth centuries, suggest that it represents a warrior, chief, or other person of high status. Equestrian sculptures may reflect the military importance of horses in the Western Sudan.

In the Indiana University Art Museum (76.98.1). Height: 24.4 cm (9.6 in.). Photograph by Michael Cavanagh and Kevin Montague

Until the early 1400s, Mali's military strength held the extensive empire together. Then, faced with revolts and attacks by rivals to gain control of the wealth, Mali began to collapse. By the middle of the sixteenth century, the political domination of the kingdom of Mali in West Africa had evaporated. As Mali declined, another powerful kingdom was on the rise.

As EARLY AS 1375, MALI'S EMPIRE was threatened by the rulers of Songhai, who refused to pay tribute. In its early days, Songhai was a small chiefdom of fisherman, farmers, and hunters living along the eastern branch of the Niger River. The fishermen plied their trade in large canoes, which served as military craft when needed. As its involvement in trans-Saharan trade increased, the kingdom of Songhai occupied and controlled greater areas of Malian territory. Sunni Ali, a renowned and powerful Songhai king, inherited the throne in 1464 and reached still farther into neighboring lands to establish control of a huge trading network. Said to possess magical powers, Sunni Ali never suffered a major defeat in his twenty-eight-year reign.

Askia Muhammad, successor to Sunni Ali, continued Songhai's expansion. The growing empire wrested control of the Western Sudan from Mali in the late fifteenth century and then began expanding its rule to the north and east. Under the Songhai rulers, it appears that the artistic and cultural traditions of the earlier kingdoms of the region endured.

During the sixteenth century, there was a period of almost fifty years when the kingdom was untroubled by attackers. But in 1591, an invasion from Morocco and rebellions by Songhai's subject kingdoms toppled the last of the great medieval Sudanic empires.

As West African coastal trade with Europeans increased, the importance of the trans-Saharan caravan routes declined. The grandeur and artistic splendor of the kingdoms of the Western Sudan faded into history, kept alive only through the ancient tales sung by the griots.

The Art of West African Kingdoms

The Hausa States

Over the centuries that the great kingdoms of Ghana, Mali, and Songhai reigned, several smaller, but powerful, Islamic kingdoms controlled the regions to the east and south. Through the sixteenth and seventeenth centuries, the Hausa states, in what is now northern Nigeria, were among those that prospered.

The Hausa states never formed a single, centralized government. As in many Islamic cultures, Hausa life was organized around towns and cities, which were hubs for trade and government and provided safety. Inside the high, thick walls of Hausa towns lived the ruler and his court, warriors, and artisans, including smiths, leatherworkers, weavers, and dyers. The town's food was produced by a surrounding circle of slave villages. Cavalry defended the towns. Soldiers wore fine helmets and coats of chain mail; quilted armor protected their horses and resembled that which is still present at the royal courts in modern-day Hausaland (fig. 4).

Hausa art, strongly influenced by Islamic strictures that prohibit the creation of images, is primarily expressed in surface decorations; Hausa objects display elegant designs, complex geometric patterns, sumptuous colors, and fine textures. These qualities are evident in the *riga*, a man's embroidered ceremonial gown fashioned from strips of woven cloth (figs. 5 and 6), and the horses' quilted armor.

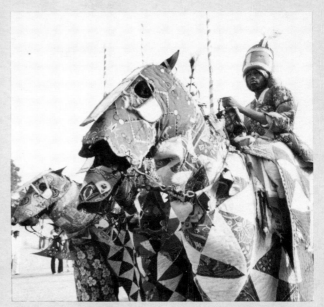

Fig. 4. Hausa cavalry, Niamey, Niger. Well-trained horsemen were a key part of the military might of many Sudanic states between the fifteenth and nineteenth centuries. Quilted armor protected Hausa warriors and their horses, especially from the poisoned arrows used by some northern Nigerian peoples.

Photograph by Eliot Elisofon, 1970

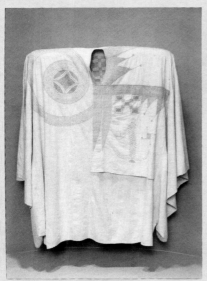

Fig. 5. Hausa embroidered man's robe, Nigeria. A Hausa riga is made by sewing together numerous cloth strips that have been woven on a narrow-band loom. The elaborately embroidered designs refer to knowledge and power.

In the National Museum of African Art (78-15-5). Height: 141 cm (55.5 in.); width: 264 cm (104 in.).
Photograph by Kim Nielsen

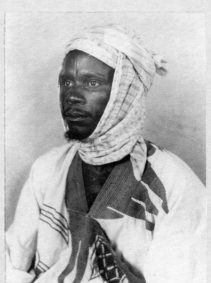

Fig. 6. Hausa trader wearing a riga, Nigeria.
Photograph by C. C. Roberts, c. 1930

AFRICA

Volta R.

Ouémé R.

So R.

Couffo R.

Benue R.

Niger R.

Pra R.

Cross R.

•Kumasi

ATLANTIC OCEAN

| 0 | 20 | 40 | 60 | 80 | 100 | | 150 | | 200 | | 250 Miles |
| 0 | 50 | | 100 | 150 | 200 | 250 | 300 | 350 | | 400 Kilometers |

B.C.

3500 3000 2500 2000 1500 1000 500 0 500

A.D.

500 600 700 800 900 1000 1100 1200 1300 1400 1500 1600 1700 1800 1900

Egyptian Kingdoms

Nok

Kingdom of Ghana

Kingdom of Mali

Kingdom of Songhai

Hausa States

Mossi States

Kanem-Bornu

Kingdom of Asante

Kingdom of Dahomey

Yoruba kingdoms

Classical period of Ife art

Igbo-Ukwu

Classical period of Owo art

Kingdom of Benin

Classical period of Benin art

Reign of
Alexander the Great
(336–323 B.C.)

Birth
of
Christ

Fall of
Roman Empire
(476)

Rise of Islam

Norman conquest
of England
(1066)

Marco Polo
in China
(1271–1292)

Columbus lands
in Western
Hemisphere (1492)

American
Revolution
(1775–1783)

American
Civil War
(1861–1865)

European nations partition Africa at Conference of Berlin (1884–1885)

The Kingdom of Asante

THE ASANTE ARE THE LARGEST and most powerful group of the Akan-speaking peoples who live in the southern part of present-day Ghana. Traders once called the area the Gold Coast because of its rich deposits of the precious metal. In contrast to some of the other kingdoms discussed in this book, the Asante kingdom still thrives today, although now within the political structure of a modern nation.

Much is known of Asante culture and royal arts. Artisans still fashion traditional art for the court, and the Asante people look to their chiefs for guidance. The court is replete with the regalia of state and leadership.

Akan people have inhabited the region since the first millennium A.D. They lived in a number of chiefdoms that were continually at war with each other for control of the land's wealth. In the seventeenth century, the Asante chief Osei Tutu called a meeting of neighboring leaders to form a federation. Oral tradition relates that an Asante priest then caused a golden stool to descend from the sky onto Osei Tutu's knees. This is said to have persuaded the other chiefs to bury their own regalia in acknowledgment of the domination of the Asante. In return for contributions of money and manpower, the other chiefs were free to rule their kingdoms without fear of attack.

The legend explaining the origin of the Golden Stool is the central myth of the Asante. The people believe that the stool contains the soul of the nation and that their fate is bound to it. They regard the Golden Stool as a sacred object, never allowing it to touch the ground. On ceremonial occasions, it is placed on its own royal chair, and when not in use, it is stored in a special room (fig. 7).

The present Golden Stool is not the original one. The first stool was made of solid gold, according to oral tradition, and may have been melted down in the late eighteenth century to pay for wars. A wooden stool sheathed in gold replaced the first. In 1896, during an Asante uprising against the British, the British threatened to sit upon the stool, thereby desecrating it. To protect the Golden Stool, it was buried in a location known only to its Asante caretakers. In 1921, as workmen constructing a road approached the secret burial site, the Golden Stool was once again rescued by the Asante.

Asante Stools

Just as the Golden Stool is a symbol of the Asante nation, a personal stool is closely linked with the individual. Among the Asante, as well as among the Akan people in general, a stool is a sacred possession associated with the soul of the owner. As soon as a child begins to

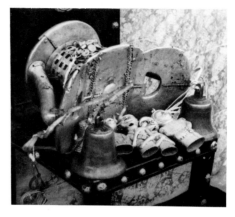

Fig. 7. Asante Golden Stool, Ghana. The Golden Stool, placed on its side, is displayed on a seat of honor at annual ceremonies. The stool is made of wood and covered with gold sheets. Attached to it are gold figures representing defeated enemies and brass bells. The Golden Stool differs in form from modern Asante stools (see fig. 8), probably reflecting its seventeenth-century origin.

Photograph by Kumasi Cultural Center Museum, Ghana

crawl, he receives a stool, and stools are often betrothal gifts. "There are no secrets between a man and his stool," notes a well-known proverb. When not in use, a stool is tilted on its side so that no other spirit can possess it.

Stools used in the home are carved from wood, while court stools usually are embellished with gold or silver and have ornaments, such as bells and talismans, to add spiritual power (figs. 8 and 9). The stool of a chief is identified with the office as well as the man. Upon his installation, a new chief commissions a stool to symbolize the position he is taking. When a chief dies, his stool is blackened and stored in a special room. There it becomes the dwelling place of his spirit.

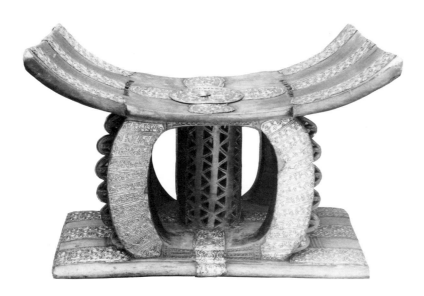

Fig. 8. Asante chief's stool, Ghana. This chief's stool with silver overlay is an example of twentieth-century Asante stools. Common household stools generally lack metal embellishment, but they may be carved with decorative low-relief designs.

In the Prempeh II Jubilee Museum, Ghana. Height: 38.74 cm (15.25 in.). Photograph by Eliot Elisofon, 1970

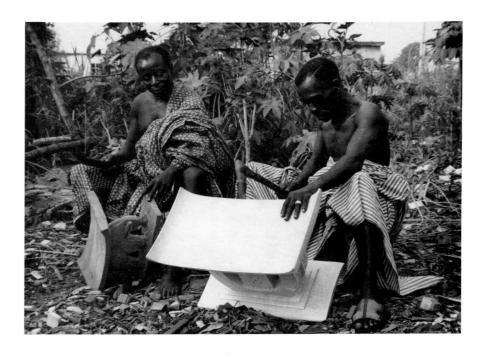

Fig. 9. Asante men carving stools, Ghana.

Photograph by Eliot Elisofon, 1971

The Art of West African Kingdoms

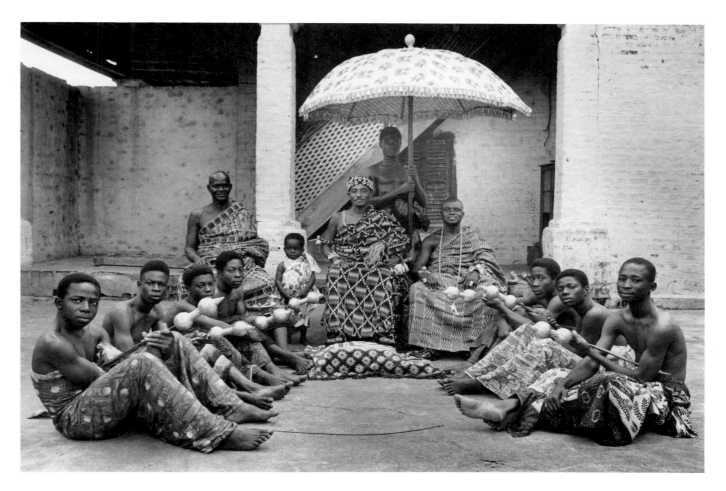

Fig. 10. Asante chief and his retainers, Kumasi, Ghana. The chief, center, and another official, right, wear multicolored kente cloths. Left, a man wears a stamped adinkra cloth. The attendants hold ceremonial swords with gold-covered hilts.

Photograph by Eliot Elisofon, 1970

The Asante Royal Court

Under a silk umbrella and dressed in a voluminous toga-like garment of many colors, an Asante ruler is a splendid figure to behold (fig. 10). The details of the regalia—the rings on his fingers, the ceremonial swords, the finials atop the umbrellas—add to the exuberant display. The hierarchy of Asante chiefs has a long and stable history, and many chiefs still use almost all of their regalia.

The old palace complex of the Asante kingdom was spread over five acres of Kumasi, the capital city. Walls of wattle and daub—a framework of woven poles and branches covered with clay—were painted with whitewash and, along the lower portions, red ochre. Designs were molded in relief on the walls, and roofs were thatched. Small windows were covered with wooden latticework (fig. 11).

Among the examples of royal furniture are beautifully carved, brass-studded wooden chairs called *akonkromfi* (fig. 12). These chairs show the stylistic influence of chairs made in Europe in the seventeenth century, which the Asante were aware of through trade. When a chief holds an audience, he may sit on one of these handsome late-Renaissance-style chairs.

The highest chief of the Asante is called the Asantehene. The Golden Stool and the Asantehene's regalia are regarded as state heirlooms, or "stool property," for which the reigning Asantehene is

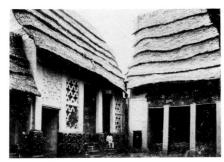

Fig. 11. Buildings surrounding a courtyard of the Asante palace, Kumasi, Ghana. The painted clay relief designs on the lower sections of the façades, the latticework upper sections, and the layered thatched roofs are architectural decorations reserved for royal and religious structures.

Photograph from Basel Mission Archives, 1901

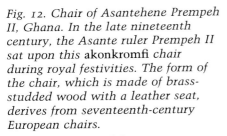

Fig. 12. Chair of Asantehene Prempeh II, Ghana. In the late nineteenth century, the Asante ruler Prempeh II sat upon this akonkromfi chair during royal festivities. The form of the chair, which is made of brass-studded wood with a leather seat, derives from seventeenth-century European chairs.

In the Prempeh II Jubilee Museum, Ghana.
Photograph by Eliot Elisofon, 1971

the trustee. To avoid a conflict of interest, each Asantehene before his installation places his property with a custodian, with the exception of one item that he donates to the regalia. Such gifts have so increased the royal treasury that now several sets of ceremonial attire are available.

Beautiful Fabrics

When a chief attends a ceremony, a generous swath of silk, intricately woven in patterns of bright colors, drapes his body (see fig. 10). A retinue of specialists accompany him: criers, bodyguards, sword-bearers, shield-carriers, whisk-wavers, drummers, and bell-ringers. Those who wear silk follow strict sumptuary laws, which dictate that the weave and pattern of a chief's clothing are to be the finest.

The Art of West African Kingdoms

Before raw silk was widely available, craftsmen painstakingly unraveled the silk and taffeta fabrics brought by European traders and then rewove the thread into Asante patterns. The Asante cherished their looms and considered it bad luck to break or burn an old one. Male weavers worked on narrow looms, weaving cloth in strips "about three fingers wide" and nine feet long. (Even today, women only prepare the yarn, while men do the weaving.) Cotton, which was locally available, also was woven in narrow strips, and sometimes silk or linen thread was used to weave patterns with the cotton. Twenty-four strips sewn together provided a length of fabric suitable for a royal garment.

The Asante name for the type of material constructed from strips with complex woven patterns is *kente* (see fig. 10). Such Asante textiles are renowned for the beauty of their color and design.

For another type of cloth, called *adinkra*, a pattern was stamped onto plain imported cloth (see fig. 10). Stamps were carved from hard calabash shells and dyes were made from tree bark. There were many stamp designs: geometric patterns, stylized plants and animals, and abstract figures representing a proverb or story. Cloth was usually stamped in a bold combination of patterns, but sometimes a chief made a declaration of policy by appearing in a cloth stamped with a single design. Colors were also symbolic. Mourning robes, for example, were subdued hues of brown, black, or brick red (representing eyes red from grief). More recently, bright colors have marked the adinkra fabric as wear for special joyous occasions.

Ceremonial Swords

Asante ceremonial swords are flamboyantly styled (fig. 13). A sword's open-worked blade is curved like the blade of a scimitar, and its hilt is covered in gold leaf. Some swords are made with two or three blades or hilts. Attached to the swords may be gold or brass ornamental masks and heads, some of which are symbolic representations of defeated enemies. Ceremonial swords serve many functions: a chief is installed with the touch of a sword; generals receive swords as badges of office; royal messengers and ambassadors carry them to identify themselves; and costumed bearers display them during affairs of state.

The Royal Linguist

One of those closest to a chief is not a member of the royal household. He is the linguist, who is appointed for his ability "to make the chief's words sweet." As the intermediary between the chief and those who wish to address him, the linguist repeats the words of both speakers and adds embellishments and appropriate maxims.

A linguist's long staff is capped with a gilded finial that often represents a proverb related to kingship (fig. 14). A finial depicting a man receiving a boost from another to climb a tree reminds a chief that "one who climbs a good tree always gets a push." And to someone contemplating the overthrow of a chief, a finial portraying two men at a dinner table offers a warning: "The food is for the man who owns it, not for the man who is hungry."

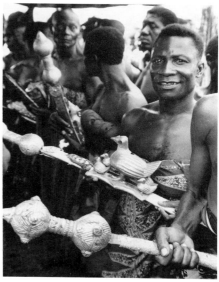

Fig. 13. Asante royal attendants with ceremonial swords, Kumasi, Ghana. The wooden hilts of the swords are covered with gold leaf and often have gold ornaments attached.
Photograph by Eliot Elisofon, 1971

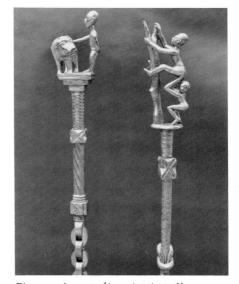

Fig. 14. Asante linguists' staffs, Ghana. Finials of staffs depict figures that represent proverbs associated with kingship. Left, a man petting a lion could refer to the proverb "When a man offends a chief in all innocence, he should be forgiven." Right, a man receiving help in climbing a tree reminds a chief that "one who climbs a good tree always gets a push."

In the Ghana National Museum (59.1046; 62.1020). Height: left, 160.02 cm (63 in.); right, 158.75 cm (62.5 in.).
Photograph by Eliot Elisofon, 1970

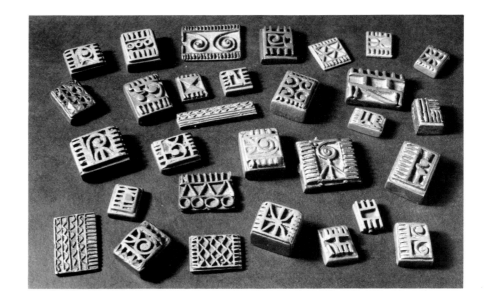

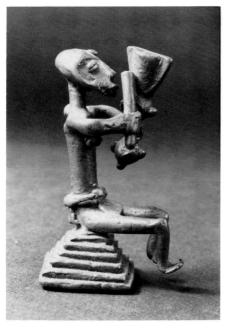

Fig. 16. *Asante brass figurative goldweight, Ghana. Figurative Asante goldweights of the eighteenth and nineteenth centuries were often associated with proverbs referring to aspects of human behavior. The proverb associated with this goldweight, which depicts a woman striking a gong, is unknown, although it may be associated with women's initiation rites.*

In the National Museum of African Art (73-7-194). Height: 6.68 cm (2.6 in.). Photograph by Eliot Elisofon, 1972

LTHOUGH THE ASANTE ARE THE dominant Akan-speaking group and a great deal is known about their particular art, much art in the region is characteristic of other Akan peoples besides the Asante.

Akan art is pointedly verbal. The language abounds in proverbs and puns; the art, with an astonishing variety of human and animal images, frequently serves to remind people of stories and moral precepts. To a member of an Akan kingdom, a simple horsetail fly whisk carries the message that there is a responsibility to contribute to a function even if one is unable to attend: "If a horse does not go to war, its tail does." A ring or finial in the form of an elephant reminds of the proverb "He who follows the trail of an elephant never gets wet from the dew," which implies that one is most protected when following the chief's rule.

Weighing Gold

By the fifteenth century, Arab and European traders commonly used gold dust as currency. The dust was weighed on a simple balance scale against a counterweight that had a precise value. Each trader owned a set of graduated weights made from seeds, ceramic beads, or cast brass. The weights made of brass are generally referred to as goldweights.

Of all the types of Akan art, the goldweight displays the greatest variety of forms. Goldweights were cast from brass into geometric and figurative shapes. They demonstrate how, through the brilliance of an artist's conception, a functional object becomes a work of art.

At first the Akan cast their goldweights, usually no more than two and one-half inches at the widest point, in the geometric shapes used by the Arab traders for their weights (fig. 15). Gradually, artistic innovation took over. Goldweights took images from nature, such as birds, fish, grasshoppers, elephants, crocodiles, leopards, and lions. Human figures were also represented (fig. 16), some as elaborate as a procession of musicians or a ruler riding in his palanquin. Today, about three million of the weights are in existence.

Goldweights were cast by the lost-wax method. In this procedure,

The Art of West African Kingdoms

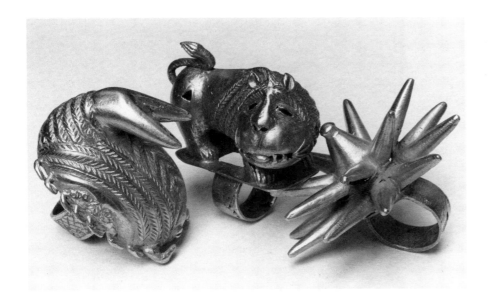

Fig. 17. Asante royal gold rings, Ghana. Rings are an important part of the regalia of an Asante chief. The lion and scorpion images refer to royal prerogatives: the right of ultimate power and the ability to take strong action when necessary.

Photograph by Eliot Elisofon, 1970

a core of clay is modeled to a size slightly smaller than that desired for the finished work. The core is covered with a layer of wax, which is then carefully detailed. The wax-covered core is enclosed in a clay investment, but a hole is left in the outer layer of clay as a channel to the core. As the entire mold is heated, the melted wax is drained from the mold through the hole. Molten brass is poured into the hardened mold. When the metal has cooled and hardened, the baked clay is broken away to reveal the cast object.

Akan Jewelry

Akan men and women prize jewelry whether it is made from gold or glass beads. Not only is jewelry a sign of wealth and status, but it is believed to have powers to cure and protect: a charm in the shape of a lock and key could provide security; an animal tooth indicates power; and bells summon spirits. Even the Asante chiefs carry beads as amulets to protect them as they move through crowds.

Gold rings were often made in the form of animals that had well-known associations. For example, mudfish—fish that can survive without water and that estivate in the muddy beds of dried-up rivers—suggest help, nourishment, and protection, while a scorpion conveys the threat of a sting (fig. 17). Chiefs in regalia wear rings that communicate different observations on royal power (fig. 18). Sometimes a chief may wear a ring on each finger. A ring with a bird's nest offers assurance that when the chief ventures away, he will return like a bird to the nest. A cocoon on a ring symbolizes the saying "It is a puzzle to know how the caterpillar entered its cocoon; did it build it before entering it or did it build the cocoon around itself?" It affirms that the chief's power derives both from the office and the man.

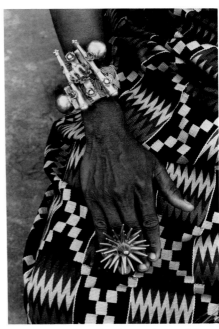

Fig. 18. Asante chief wearing gold ring and gold bracelet, Ghana. The chief's hand rests against his kente cloth garment.

Photograph by Eliot Elisofon, 1970

For centuries, the Asante, as well as other Akan peoples, have maintained their culture. Today, they create and use works of art much as they always have. The powerful kingdoms and royal arts of Africa's past are evoked by the still-vibrant culture of the Asante.

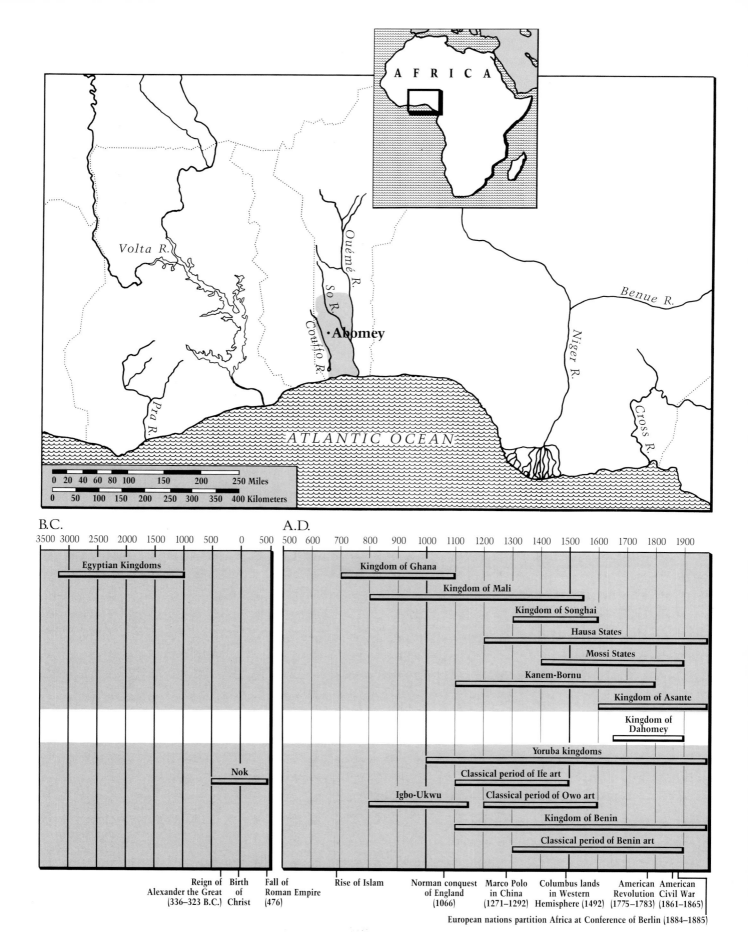

AFRICA

Volta R.

Ouémé R.

So R.

Couffo R.

•Abomey

Benue R.

Niger R.

Cross R.

ATLANTIC OCEAN

0 20 40 60 80 100 150 200 250 Miles

0 50 100 150 200 250 300 350 400 Kilometers

B.C.

3500 3000 2500 2000 1500 1000 500 0 500

Egyptian Kingdoms

Nok

A.D.

500 600 700 800 900 1000 1100 1200 1300 1400 1500 1600 1700 1800 1900

Kingdom of Ghana

Kingdom of Mali

Kingdom of Songhai

Hausa States

Mossi States

Kanem-Bornu

Kingdom of Asante

Kingdom of Dahomey

Yoruba kingdoms

Classical period of Ife art

Igbo-Ukwu

Classical period of Owo art

Kingdom of Benin

Classical period of Benin art

Reign of Alexander the Great (336–323 B.C.)

Birth of Christ

Fall of Roman Empire (476)

Rise of Islam

Norman conquest of England (1066)

Marco Polo in China (1271–1292)

Columbus lands in Western Hemisphere (1492)

American Revolution (1775–1783)

American Civil War (1861–1865)

European nations partition Africa at Conference of Berlin (1884–1885)

3

The Kingdom of Dahomey

Conflict led to the emergence of the kingdom of Dahomey in the late seventeenth century. The Fon people, besieged by African slave raiders to the south and the fierce horsemen of the Yoruba kingdoms to the east in what is now Nigeria, formed the kingdom and its inland capital, Abomey, to provide for their defense. In this thinly wooded and difficult to defend region, now part of the Republic of Benin, the Fon developed a militaristic state: women served as soldiers in the kingdom's army; the king exercised direct control over the production and distribution of strategic materials such as food and medicine; and an individual's social status was determined by demonstrated military abilities and exploits. By the early eighteenth century, during the same time as the ascendancy of the Asante kingdom, Dahomey had conquered the coastal states to the south; by 1818 the kingdom had also thrown off the yoke of Yoruba domination. Even today, however, many Yoruba people continue to live in the region.

The arts of the kingdom of Dahomey, like those of Asante, reflect the importance of leadership. As in other African kingdoms, the Fon royal court controlled the creation and production of art. The use of imported cloth and silk, for example, was limited to members of the royal court. The Fon built wattle-and-daub palaces and produced such royal objects as figurative wood and metal sculptures, large umbrellas, banners, and elaborate regalia.

Although some nearly life-size sculptures in wood and metal were created by Fon artists for the royal court (fig. 19) and pictorial reliefs decorated the outside walls of the royal palaces in Abomey (fig. 20), the most important arts of the kingdom were those associated

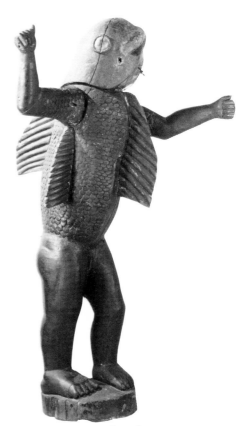

Fig. 19. Fon wood sculpture, Dahomey Kingdom, Benin. King Behanzin of the kingdom of Dahomey, who reigned from 1889 to 1892, is depicted as a shark in this nearly life-size sculpture. Most African sculptures are made from a single piece of wood, but this work is composed of many pieces that have been carved separately and joined together.

In the Musée de l'Homme, France (93.45.3). Height: 160 cm (63 in.).

Fig. 20. Fon earthen relief murals, Dahomey Kingdom, Benin. Relief murals on the deteriorating walls of a palace in Abomey, photographed in 1937, show traces of the paint with which they were originally finished.

From the Herbert V. and Eva L. R. Meyerowitz Collection, Eliot Elisofon Archives.

Photograph by Herbert V. Meyerowitz, 1937

Fig. 21. *Fon chief in ceremonial regalia, Abomey, Dahomey Kingdom, Benin. A Fon chief wearing a decorated hat is carried on a palanquin by attendants. Appliqué images on the umbrellas identify the ruler and refer to his military exploits.*

From the Melville J. and Frances S. Herskovits Collection, Eliot Elisofon Archives.

Photograph by M. T. G. Thiévin, 1931

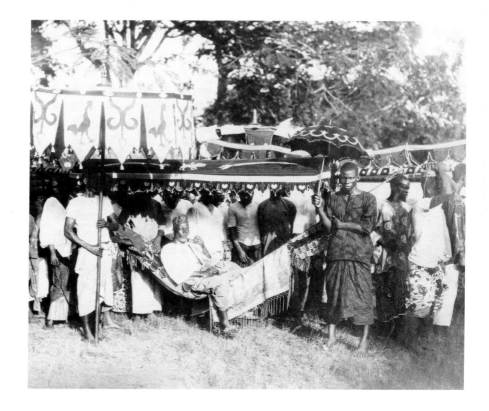

with ceremonial display. At annual court ceremonies, thousands of citizens representing every village would witness processions displaying the king's wealth and the goods to be distributed to those who served the king. These vast outdoor ceremonies, held before the gates of the palace, were enhanced by the spectacular display of large, colorful appliqué-decorated textiles. Officials wore decorated hats, large umbrellas sheltered rulers and their entourages, and huge banners hung from buildings and pavilion rooftops (fig. 21). A British visitor at the time of the annual ceremonies in 1850 described and illustrated a crimson, tent-shaped pavilion that was "ornamented with emblems of humans and bullock heads, skulls and other devices of native make" (fig. 22).

The images that decorate Fon banners, umbrellas, and other cloth items—figures of men in battle, hunting scenes, weapons, and animals capturing or devouring other animals—emphasize themes of power in social roles, relationships, and situations (figs. 23 and 24). Upon taking office, a king or chief received imported white cloth to be filled during his lifetime with images associated with his honorific titles and military exploits.

Guilds of royal tailors used templates to fashion appliqué forms and to make copies of worn dynastic cloths. Sets of images could refer to proverbs associated with events or allegorical descriptions of a ruler's superhuman abilities. A duck on the cloth of a late-nineteenth-century king, for example, refers to the ruler's magical ability to survive after drinking the blood of a duck, believed to be poisonous.

As in Asante royal arts, the visual and verbal arts joined to reinforce the power of authority. An appliqué cloth attracted attention as a striking visual form; the verbal arts, however, explained the full meaning of the images.

Fig. 22. Fon tent pavilion, Dahomey Kingdom, Benin. Large tent pavilions were used during the nineteenth century for annual ceremonies during which the king of Dahomey would distribute wealth to loyal chiefs. This nineteenth-century illustration depicts a tent made from imported European cloth and decorated with locally made appliqué images.

Illustration published in Dahomey and the Dahomans, by Frederick E. Forbes, 1851.

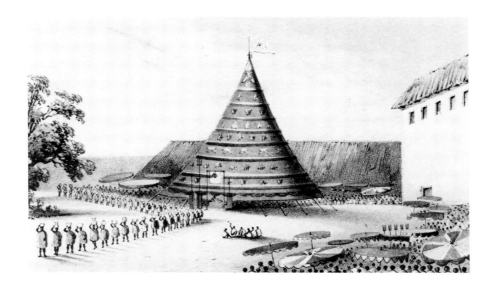

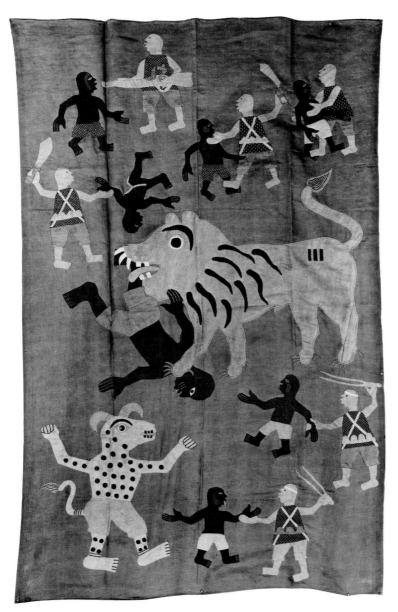

Fig. 23. Fon appliqué cloth banner, Dahomey Kingdom, Benin. The appliqué banners that were displayed by Fon rulers emphasize themes of power. In this banner, soldiers engage in battle and a lion, representing a late-nineteenth-century king, attacks a person.

In the Musée des Arts Africains et Océaniens, France. Length: 220 cm (86.6 in.).

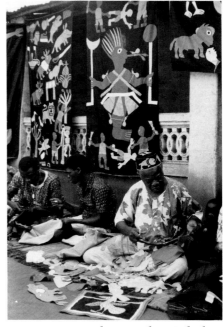

Fig. 24. Men making appliqué cloth, Abomey, Benin.

Photograph by Eliot Elisofon, 1971

The Kingdom of Dahomey

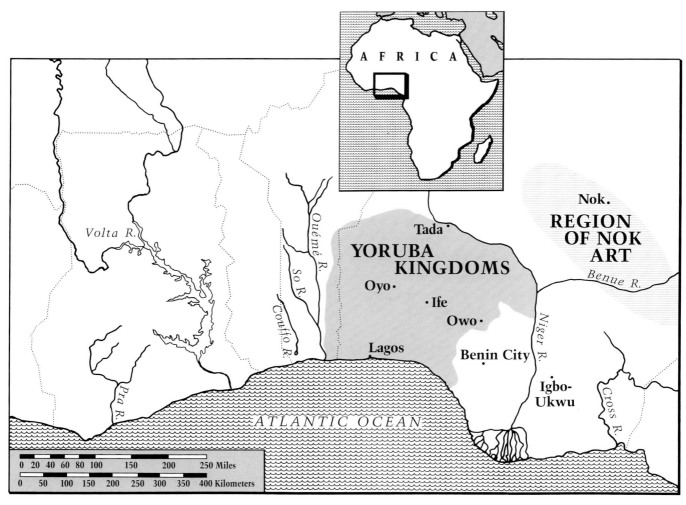

AFRICA

Volta R.

Ouémé R.

So R.

Couffo R.

Tada

YORUBA KINGDOMS

Oyo

• Ife

Owo •

Lagos

Benin City

Niger R.

Nok •

REGION OF NOK ART

Benue R.

Igbo-Ukwu

Cross R.

Pra R.

ATLANTIC OCEAN

| 0 | 20 | 40 | 60 | 80 | 100 | 150 | 200 | 250 Miles |
| 0 | 50 | 100 | 150 | 200 | 250 | 300 | 350 | 400 Kilometers |

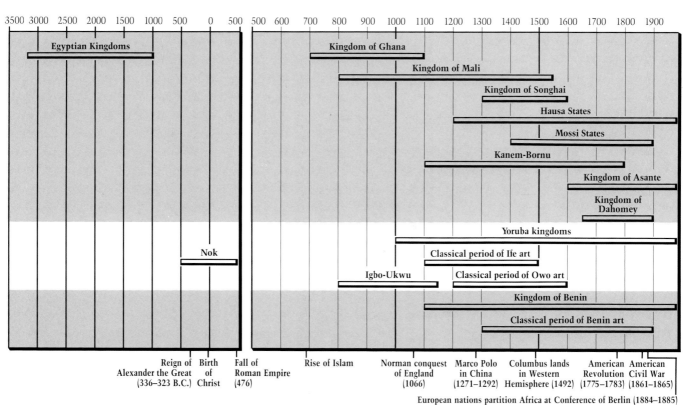

3500 3000 2500 2000 1500 1000 500 0 500 | 500 600 700 800 900 1000 1100 1200 1300 1400 1500 1600 1700 1800 1900

Egyptian Kingdoms

Kingdom of Ghana

Kingdom of Mali

Kingdom of Songhai

Hausa States

Mossi States

Kanem-Bornu

Kingdom of Asante

Kingdom of Dahomey

Yoruba kingdoms

Classical period of Ife art

Nok

Igbo-Ukwu

Classical period of Owo art

Kingdom of Benin

Classical period of Benin art

Reign of Alexander the Great (336–323 B.C.)

Birth of Christ

Fall of Roman Empire (476)

Rise of Islam

Norman conquest of England (1066)

Marco Polo in China (1271–1292)

Columbus lands in Western Hemisphere (1492)

American Revolution (1775–1783)

American Civil War (1861–1865)

European nations partition Africa at Conference of Berlin (1884–1885)

4

The Yoruba Kingdoms

YORUBA CULTURE AND ART HAVE their roots in the ancient kingdom of Ife. For at least seven hundred years, from the ninth century through the fifteenth century, Ife was the religious and political center of the Yoruba people. The splendid commemorative portrait sculptures of Ife's kings, queens, and people of elite status offer only a glimpse of what was the most influential kingdom in the region that is now southwestern Nigeria.

The terra-cotta and metal sculptures of the kingdom of Ife are unique in African art because of their extraordinary naturalism. When the first sculptures were found in the contemporary Yoruba city of Ife early in this century, there was no known African precedent for them, so scholars postulated a connection between Ife and the ancient cultures of the Mediterranean. But as more examples were unearthed, amassing a remarkable collection of heads and full-length figures, comparative scholarly studies made it clear that the works were purely African in origin.

Little archaeological data exist concerning Ife culture. Despite the abundance of art objects, therefore, the precise origins of Ife art remain obscure. The art of two neighboring cultures that are known only through archaeological discoveries, Nok and Igbo-Ukwu, as well as the art of other little-known ancient cultures, may have influenced the development of the art of Ife (see box p. 32).

An Ife Creation Myth

Ife is the earliest Yoruba kingdom to be celebrated in oral tradition. According to tradition, Ife was founded by the deity Oduduwa, who descended from the heavens on an iron chain. Reaching the primordial ocean, he emptied a calabash containing sand and released a chicken. The chicken scattered the sand across the waters, causing land to appear. The spot where Oduduwa stood was Ife, and he became the first *oni*, or ruler, of Ife. Later, Oduduwa sent his sixteen sons to found other kingdoms, which retained religious and political allegiance to Ife through the oni, who was both priest and king. Even today, the oni of Ife holds a spiritual charisma for all of the Yoruba people.

Historians view the Ife creation myth as an indigenous explanation and recognition of the relationship between the numerous modern Yoruba kingdoms and Ife. Although there is disagreement over how the myth can be interpreted, certain facts seem certain. By the fifteenth century, city-states with a fair degree of centralized political, economic, and religious organization had come into existence in the region, vying with one another for power. Ife was one of the most powerful and dynamic of these city-states.

The Art of Nok and Igbo-Ukwu

The art of Nok, named after the village where artifacts were first discovered by archaeologists in 1943, flourished in north-central Nigeria between 500 B.C. and A.D. 500. Other than the information that can be gleaned from the sculptures and a few other artifacts that have been discovered, the culture remains shrouded in mystery. It is known that in their agriculturally based society, the people had ironworking technology. They also created hollow terra-cotta sculpture of men, women, and animals (fig. 25). The sculptures of human figures are portrayed in garments and jewelry that are characteristic of royalty, but it has not been determined whether the people of the region actually formed a kingdom. Little else is known about the people and their political organization.

A second outstanding artistic tradition that existed near Ife as early as the ninth century was discovered in the 1950s in excavations at a village called Igbo-Ukwu in the eastern part of Nigeria. Cast by the lost-wax method, the metal sculptures found there are splendidly decorated, some with glass and stone beads, and show an extraordinary mastery of technique (fig. 26). A few objects are so intricately fashioned that they were first cast in parts and then joined (fig. 27). Since the raw materials for these sculptures were unavailable locally, they were most likely imported. This suggests that Igbo-Ukwu may have been involved in the early trade with North Africa. While the quality of workmanship and combinations of materials are characteristic of royal art, the nature of the society that created them is as yet unknown.

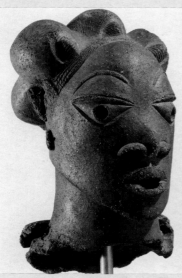

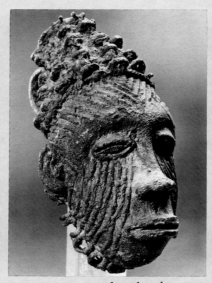

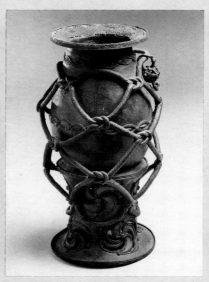

Fig. 25. Nok terra-cotta head, Rafin Kura, Nigeria. This hollow terra-cotta head from the Nok area may have been part of a full-length figure. The pierced eyes, nostrils, and mouth, triangular eyes, curved eyebrows, and elaborately detailed coiffure are characteristic of Nok sculptures.

In the Jos Museum, Nigeria. Height: 35 cm (13.8 in.).
Photograph by Eliot Elisofon

Fig. 26. Brass pendant head, presumed from Igbo-Ukwu, Nigeria. This small pendant, three inches in length, depicts a human head with facial scarification. Cast in brass, the sculpture was further enhanced by attaching beads to the coiffure or crown.

In the National Museum, Nigeria. Height: 7.6 cm (3 in.).
Photograph by Dirk Bakker

Fig. 27. Bronze roped pot on a stand, Igbo-Ukwu, Nigeria. Evidence of the mastery of casting skills in ninth-century Igbo-Ukwu is seen in this sculpture. Entirely made of bronze, it was cast in separate pieces that were later joined by additional casting.

In the National Museum, Nigeria. Height: 32.3 cm (12.7 in.).
Photograph by Dirk Bakker

Ife Portrait Sculptures

Radiocarbon measurements of organic matter from archaeological excavations indicate that Ife existed in A.D. 800, if not several hundred years earlier. Thermoluminescence testing of the terra-cotta sculptures has established that they were produced between the eleventh and fifteenth centuries; the brass objects have not yet been scientifically dated. Of about thirty metal sculptures that have been found, most are life-size heads that appear to represent royalty (fig. 28). In more recent times, many of these heads were repeatedly buried, dug up for rituals, and then reburied, although this probably was not how they were originally used.

Brass for casting was expensive because it had to to be imported. Financed with tributes from neighboring kingdoms controlled by Ife, the metal probably came from North Africa or Europe. Brass was most likely cast under the exclusive authority of the king, who reserved metal sculpture for royal ceremonies; certain persons of elite status may have used terra-cotta images for their rituals. Although the heads are relatively naturalistic, the features are idealize'd. Scholars of African art speculate that they may not have been intended as true portraits of the onis, but rather as commemorative representations of them. Most of the metal heads have holes at the hairline, perhaps for attaching a crown or strings of beads to form a veil. Some also have holes around the lips and jaw that may have been used to attach a beard or mustache.

The heads were possibly placed in a shrine in the oni's palace. Some, however, have a row of holes on the neck, suggesting they could have been attached to wooden bodies to form effigies used in funeral ceremonies. (In the tropical African climate, burial often takes place the same day a death occurs. It is frequently the custom to have a ceremonial burial some time after a person's death when the family has gathered funds to pay for it or when relatives traveling from long distances arrive.)

Ife Ornamentation

Why some of the heads have facial markings and others do not remains another unanswered question. Many of the faces bear vertical striations in patterns unlike any seen in the area today. Several are incised on the lower lip, and others have deep grooves across the face. A few have "cat's whiskers" markings (fig. 29).

Partial and full-length figures of the rulers illustrate traditional regalia and provide evidence of Ife crafts, such as embroidery. Though each figure is different, there are features common to all. The crown is usually represented as beaded and tiered, bordered by a fringe of tightly curled hair. The badge of office, a vertical double-bow pendant, is depicted hanging from a collar of heavy beads; strands of finer beads cover the chest and another heavy rope of beads hangs almost to the knees. Both arms are ringed with representations of beads and metal bracelets. The king's kilt-like garment may be shown drawn to one side and hemmed around the bottom. In some sculptures, the king holds the mace of office; in his other hand he may hold a ram's horn, which once could have been used as a container for magical substances (fig. 30). Like the heads, the figures provide no indication

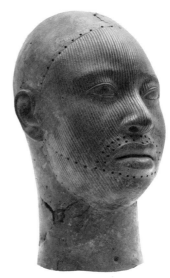

Fig. 28. Brass commemorative head, Ife, Nigeria. Commemorative heads, probably representing deceased kings of Ife, were cast in brass between the twelfth and fifteenth centuries. This sculpture shows the overall scarification that is characteristic of some heads, as well as the rows of holes at the hairline and around the lips and jaw. The holes were probably used to attach a crown, beaded veil, and beaded beard and mustache.

In the Museum of Ife Antiquities, Nigeria. Height: 26 cm (10.2 in.)
Photograph by Eliot Elisofon, 1951

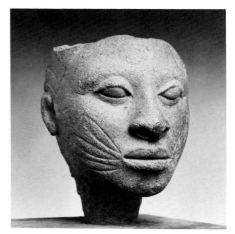

Fig. 29. Terra-cotta commemorative head fragment, Ife, Nigeria. In addition to brass, Ife commemorative heads were also created in terra-cotta. This fragment from a larger figure shows a style of facial scarification that no longer appears among present-day Yoruba peoples.

In the National Museum, Nigeria. Height: 12.5 cm (5 in.).
Photograph by Dirk Bakker

as to their purpose. Possibly, they were made for either coronations, commemorations of events, or use by a royal ancestral cult.

The Metalwork of Ife

Ife metalwork, like that of Igbo-Ukwu, was cast by the lost-wax technique. There is no information to explain how the artists of Ife learned to cast in metal. Most of the Ife sculptures are brass, an alloy of copper and zinc with traces of additional metals. The term *bronze* is often mistakenly applied to sculptures made from any copper alloy, including the brass art of Ife. But technically, bronze refers only to an alloy of copper and tin. Sometimes the Ife metalworkers used pure copper, which is difficult to work with because in its molten state it oxidizes when exposed to air.

Two of the finest works in the Ife style are copper. One is a near-perfect mask with slits below the eyes for the wearer to see (fig. 31). Tradition holds that it is a portrait of Oni Obalufon, who is said to have introduced metal casting to Ife, and that it has been kept in the palace since the time it was made, sometime between the twelfth and fifteenth centuries. The other is a twenty-one-inch seated figure from Tada in north-central Nigeria, also cast between the twelfth and fifteenth centuries (fig. 32). The figure is missing limbs and its surface is now pitted, but it remains a masterpiece.

Ornate Pavements

Although no early houses or foundations survive in Ife, several pavements have been unearthed, generally located in the same areas that yield sculptures. Paved walkways are said to have originated in Ife, according to oral tradition, when a female oni named Oluwo was splashed with mud while walking on a rainy day. Courtyard pavements also have been uncovered; often a pot is buried up to its lip in the center or at the side, possibly for ritual offerings. The pavements are composed of potsherds laid on edge in patterns, and some pavements are decorated with quartz pebbles forming intricate designs (fig. 33).

Ife artists were also highly accomplished stonecutters, able to work with a hard, intractable material such as quartz. Finely carved quartz stools survive, as do a number of stone statues.

Modern Yoruba Kingdoms

The great lack of archaeological data concerning the Yoruba kingdoms for the period between the fifteenth and nineteenth centuries allows little speculation regarding their arts. It is evident from the similarities between the early Yoruba arts and the arts of Yorubaland during the nineteenth and twentieth centuries, however, that strong artistic traditions probably continued unabated.

The Yoruba inclination for creating and settling in populous urban centers continues to the present day. Most Yoruba cities and towns are regularly patterned; various family groups live in areas that surround a central chief's compound or king's palace. The urban center attracts trade that supports court functionaries, subsistence farmers, and local craftsmen. Artworks are created in service of the court and to celebrate the gods.

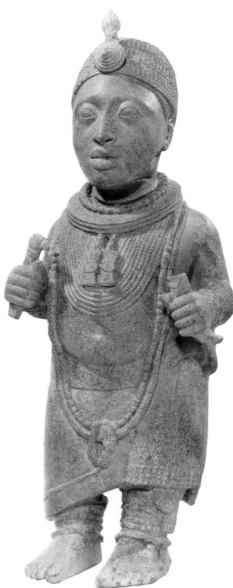

Fig. 30. Brass figurative sculpture, Ife, Nigeria. Full-length representations of rulers provide insights into the traditional regalia and garments of ancient Ife. This figure wears a tiered crown, a double-bow pendant on his chest (perhaps as a badge of office), and ropes of large and small beads around his neck, wrists, and ankles. His garment, hemmed at the bottom, is tied at the waist with a large sash.

In the Museum of Ife Antiquities, Nigeria.
Height: 44.68 cm (17.6 in.)
Photograph by Frank Willett

The Art of West African Kingdoms

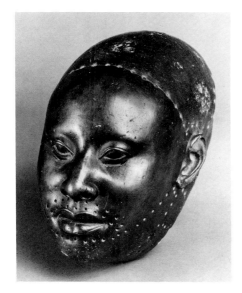

Fig. 31. Copper mask, Ife, Nigeria. This is the only mask among the known works of ancient Ife. It is also unique because it is cast of copper. Slits beneath the eyes permit the wearer to see.

In the Museum of Ife Antiquities, Nigeria. Height: 29.5 cm (11.6 in.).
Photograph by Dirk Bakker

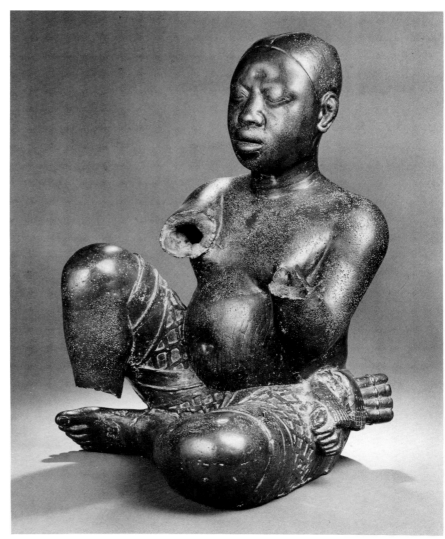

Fig. 32. Copper seated figure, Ife style, Nigeria. Cast in the Ife style of the twelfth to fifteenth centuries, this full-length figure was found almost two hundred miles north of Ife in the present-day village of Tada. Its abraded surface may be the result of weekly ritual washing with sand by local villagers.

In the National Museum, Nigeria. Height: 53.7 cm (21.1 in.).
Photograph by Dirk Bakker

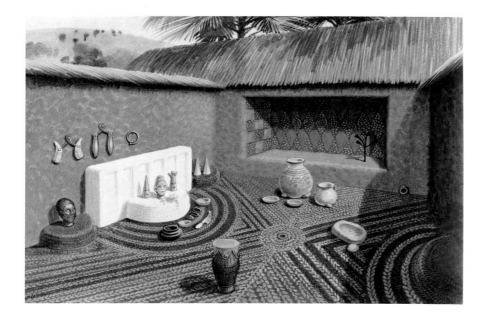

Fig. 33. Artist's rendering of courtyard with altar and potsherd pavement, Ife, Nigeria. Pavements made from small, circular potsherds laid on edge were confined to ritual areas of ancient Ife. A pot, possibly for ritual offerings, is buried up to its lip in the center of the courtyard. Some pavements used potsherds and quartz pebbles to create patterns.

Drawing by Yvonne McLean

The Kingdom of Owo

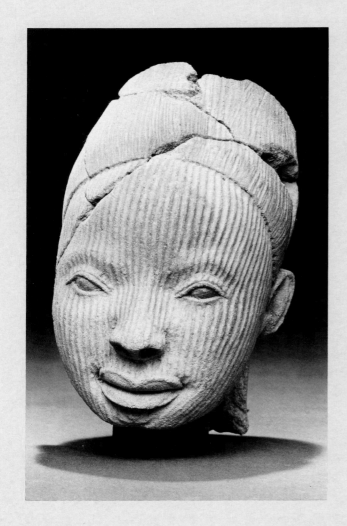

Other Yoruba kingdoms seem to have shared artistic affinities with ancient Ife. The kingdom of Owo lay along the route between Ife and Benin, another major kingdom of West Africa. According to traditional oral history, Owo was established by the youngest son of Oduduwa, Ife's founder, in A.D. 1200. A number of terra-cotta sculptures dating from the fifteenth century have been found in a sacred grove near the palace of the *olowo*, or king. Scholars see in some of these works stylistic or iconographic resemblances to art from Ife and Benin.

The terra-cotta heads from Owo, some less than five inches in length, are smaller than those from Ife (fig. 34). In numerous instances, they were originally elements of larger sculptures but have broken off. Many figures are bedecked with beads and bracelets, although images of royalty cannot be positively identified.

Fig. 34. Terra-cotta head, Owo, Nigeria. Terra-cotta heads found at Owo share many stylistic features with contemporaneous fifteenth-century Ife examples. These include naturalistic proportions, vertical facial striations, depressions at the corners of the mouth, and grooves that are parallel to the edges of the upper eyelids.

In the National Museum, Nigeria. Height: 17.4 cm (6.9 in.).
Photograph by Dirk Bakker

The Yoruba are the most prolific creators of art in sub-Saharan Africa. They number some ten million and are divided into twenty subgroups. Each is a traditionally autonomous kingdom with its own rich heritage of visual arts, music, dance, and verbal arts. Woven textiles dyed and decorated in a variety of ways are worn by men and women, and hairstyle, jewelry, and painting and scarification (patterned marks made by incisions on the skin) of the face and body are important aspects of personal aesthetic expression.

Individuals may commission sculptures for shrines dedicated to *orisha*, or spirits, of the vast traditional Yoruba pantheon or for personal use. Shrines for Shango, the spirit associated with thunder and lightning, and for Eshu, the trickster-messenger of the high god, contain many wood sculptures that represent their attendants and devotees. Carved wooden figures for the twin cult, *ibeji*, are widespread, because the incidence of infant mortality is high. The

The Art of West African Kingdoms

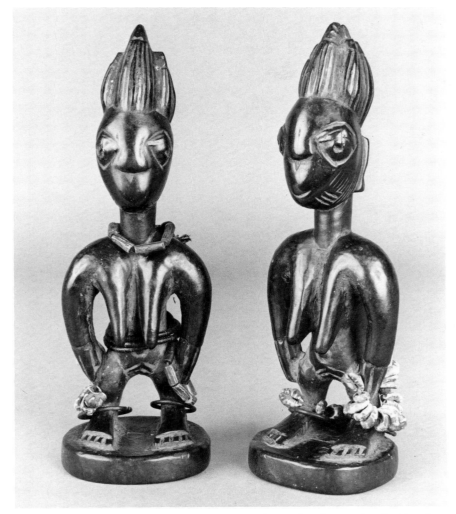

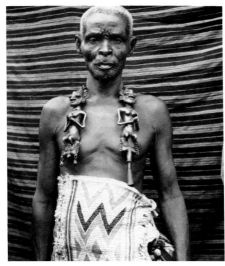

Fig. 36. Yoruba Ogboni society elder with brass sculptures (edan), Nigeria. Senior members of the Ogboni society, which checks the power of the rulers, own edan, chained sets of brass sculptures modeled around iron cores. A pair is usually made up of a male and a female figure.

Photograph by William Fagg, field season 1949-50

Fig. 35. Yoruba twin figures, Nigeria. Carved wooden figures for the Yoruba twin cult ibeji are maintained in personal household shrines. Beads, brass, and cowrie shells may be attached to a sculpture, which is regularly provided food, clothed, washed, and oiled to honor the spirit of a deceased twin.

In the National Museum of African Art (83-6-1.2; 83-6-1.1). Height: left, 27 cm (10.6 in.); right, 26.5 cm (10.4 in.). Photograph by Ken Heinen

wooden figure, believed to serve as the resting place for the soul of a deceased twin, is clothed, provided food, and treated equally with the surviving twin (fig. 35).

Metalworkers create iron and brass artworks used by herbalists, diviners, worshippers of particular religious cults, and chiefs and members of Ogboni, a society of elders that checks the power of rulers (fig. 36).

Bead embroiderers create works used by diviners, cult priests, and members of the royal court. Most spectacular among the royal regalia created by bead embroiderers are the crowns worn by kings (fig. 37). Netted bead strands suspended from a crown conceal the wearer's face, symbolically eliminating the individual personality of the wearer and replacing it with the divine power of the royal dynasty, represented by the beaded faces and birds embroidered on the objects of the regalia.

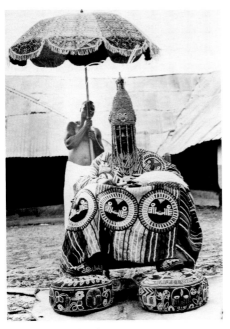

Fig. 37. Yoruba king, Nigeria. A Yoruba ruler wears a crown, a gown, and sandals embroidered with beads. A bird surmounts the crown, and coral bead strands form a veil that hides the ruler's face. His feet rest on cushions embroidered with faces similar to those on the crown.

Photograph by Eliot Elisofon, 1959

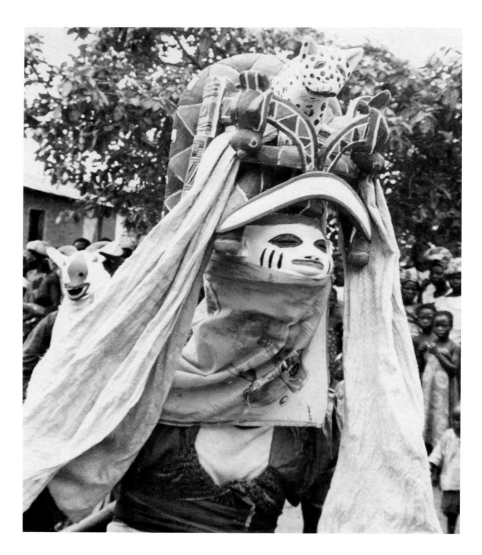

Fig. 38. Yoruba gelede masquerade performer, Nigeria. Gelede masks, usually representing women, are generally danced in pairs. They are worn by men who impersonate women's gestures and dance steps. The upper section of this mask incorporates references to the hierarchy of power in the world by depicting a leopard subduing a serpent.

Photograph by Eliot Elisofon, 1970

Masquerades

The modern Yoruba masquerade is a celebration and ritual that subsumes many art forms: dance, sculpture, music, painting, drama, costumery, and architecture.

Masks, which are carved and worn only by men, are used in masquerades. Among the Yoruba, three types of masks predominate: *gelede*, in southwestern Yorubaland, is associated with alleviating the problems caused by witchcraft (fig. 38); *epa*, in northeastern Yorubaland, is associated with fertility of the land and the people (fig. 39); and *egungun*, throughout Yorubaland, is associated with ancestors and other spirit forces that affect peoples' lives (fig. 40). Ritual preparations call upon the talents of sculptors, bead embroiderers, weavers, tailors, dancers, and musicians. Ultimately, the entire community participates, whether helping to prepare the masquerade or watching it.

For a thousand years, from Ife or earlier to the modern Yoruba kingdoms, Yoruba art has maintained an essential humanism. Images of men and women predominate, and art forms are concerned primarily with the relationship of humanity to the cosmos.

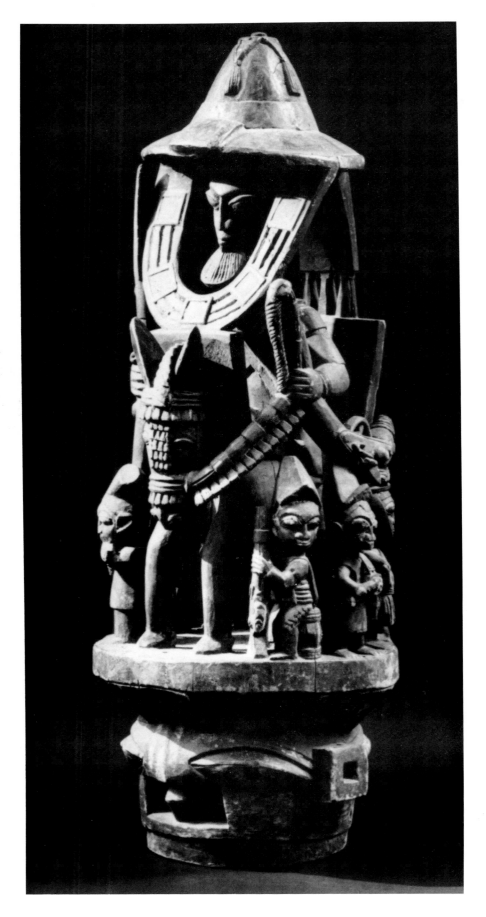

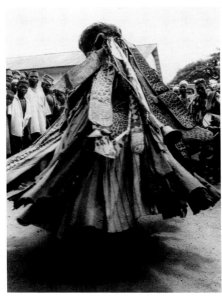

Fig. 39. Yoruba epa mask, Nigeria. At annual festivals in northeastern Yorubaland, epa masqueraders appear from the forest to dance among the townspeople, bestowing blessings on the community and honoring important lineages. Masks with images of hunters or warriors on horseback remind spectators of the importance of the warrior in ensuring a secure community.

In the Seattle Art Museum, Katherine White Collection (81.17.579). Height: 118 cm (46.5 in.).
Photograph by Ralph Marshall

Fig. 40. Yoruba egungun masquerade performer, Nigeria. Egungun masks are danced at annual festivals to honor the lineages that established a town. Many masks have no sculptured wood form, instead consisting primarily of a headpiece with panels of fabric and animal skins.

Photograph by Eliot Elisofon, 1970

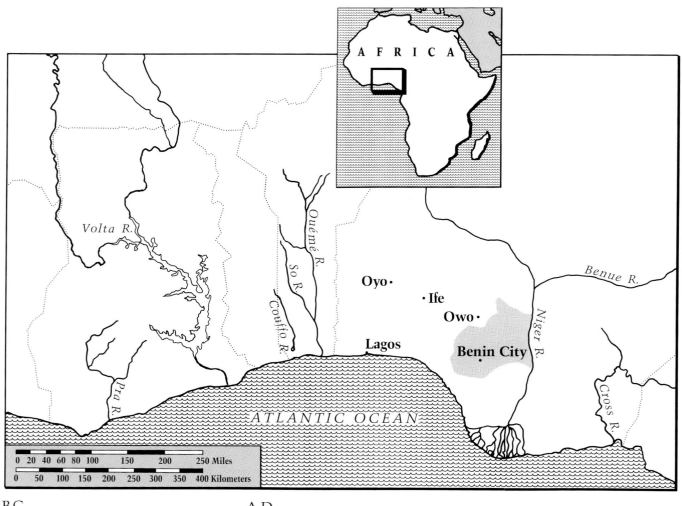

A F R I C A

Volta R.

Ouémé R.

So R.

Couffo R.

Benue R.

Oyo ·

· Ife

Owo ·

Niger R.

Lagos

Benin City

Pra R.

Cross R.

ATLANTIC OCEAN

0 20 40 60 80 100 150 200 250 Miles

0 50 100 150 200 250 300 350 400 Kilometers

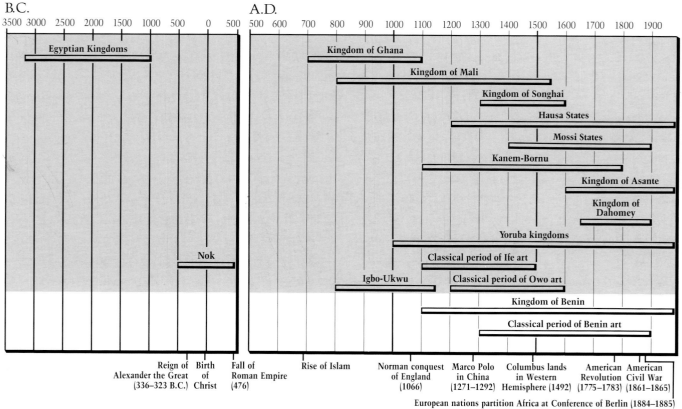

B.C.

3500 3000 2500 2000 1500 1000 500 0 500

Egyptian Kingdoms

Nok

A.D.

500 600 700 800 900 1000 1100 1200 1300 1400 1500 1600 1700 1800 1900

Kingdom of Ghana

Kingdom of Mali

Kingdom of Songhai

Hausa States

Mossi States

Kanem-Bornu

Kingdom of Asante

Kingdom of
Dahomey

Yoruba kingdoms

Classical period of Ife art

Igbo-Ukwu Classical period of Owo art

Kingdom of Benin

Classical period of Benin art

Reign of Birth
Alexander the Great of Fall of
(336–323 B.C.) Christ Roman Empire
 (476)

Rise of Islam Norman conquest Marco Polo Columbus lands American American
 of England in China in Western Revolution Civil War
 (1066) (1271–1292) Hemisphere (1492) (1775–1783) (1861–1865)

European nations partition Africa at Conference of Berlin (1884–1885)

5

The Kingdom of Benin

BENIN HAS BEEN A KINGDOM SINCE about A.D. 1100. Once a powerful city-state, Benin, situated in the tropical rain forest of what is now south-central Nigeria, still exists today in a more modest form.* While *Benin* commonly refers to the kingdom, the term *Edo* refers to the people and their language.

The highly stylized brass heads of Benin's kings are probably more familiar to Westerners than the art of other African kingdoms. Many of the heads and other works were taken from Benin in 1897 by a British punitive expedition. The expedition was mounted in response to the killing of a British vice-consul and most of his party. They were killed while traveling to Benin, despite a warning, during the annual rituals, a time for enforced seclusion of the king. In reprisal for the deaths, the British expedition occupied Benin City, the capital of the kingdom, and sent the *oba*, or king, into exile. A valuable collection of brass sculptures and carvings in ivory and wood was taken to London. Many of these works were auctioned by the British Foreign Office to private collectors and museums.

The Benin Kingdom and Ife

In the twelfth century, according to Edo tradition, the Edo people revolted against the ruling dynasty, the Ogiso, and asked their

* The kingdom of Benin has no association with the modern West African nation of Benin.

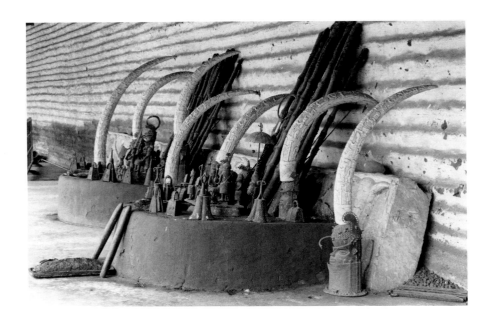

Fig. 41. Royal ancestral shrines, Benin, Nigeria. Ancestral shrines for Benin kings in the present-day palace compound display brass commemorative heads that support elaborately carved ivory tusks. Numerous ritual objects, including cast brass bells and figurative sculpture, rest atop the altars.

Photograph by Eliot Elisofon, 1970

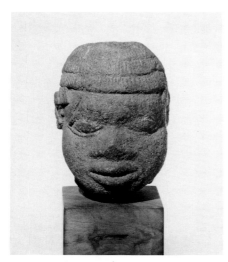

Fig. 42. Terra-cotta commemorative head, Benin, Nigeria. In their relative lack of regalia, the terra-cotta sculptures of Benin resemble royal brass commemorative heads of the fifteenth century (see fig. 43).

In the National Museum of African Art (85-19-10). Gift of Joseph H. Hirshhorn to the Smithsonian Institution. Height: 9.5 cm (3.7 in.).

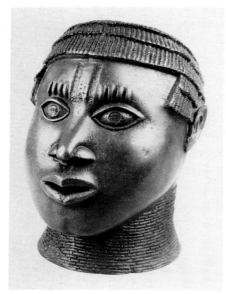

Fig. 43. Brass commemorative head, Benin, Nigeria. Brass commemorative heads for royal ancestral altars may date from the fifteenth century. Early examples, such as this one, were cast with thin walls, perhaps due to a scarcity of metal.

In the National Museum of African Art (82-5-2). Height: 23 cm (9.1 in.). Photograph by Ken Heinen

spiritual mentor, the oni of Ife, to send them a new king. Ife's oni, Oduduwa, sent his son Oranmiyan to Benin. But instead of taking the throne himself, Oranmiyan married a daughter of the old regime. Their son, Eweka, whose lineage derived from both the old and the new dynasties, became the first oba of Benin.

The Edo believed that the oba was divine and that he was descended from Osanobua, creator of the world. His power was absolute. The royal palace was once a vast compound with workshops where metalsmiths, carvers, leather-workers, and others served the oba. The casting of brass, in particular, was a royal art. The king controlled the prized material; anyone found casting brass without the king's permission faced death.

Ancestral Commemoration

Fundamental to Edo belief was the veneration of ancestors, whose spirits were thought to protect the living. Every important Edo family had a shrine for its clay or wood ancestral imagery. In the royal palace, cast metal commemorative heads of deceased obas were displayed at numerous shrines (fig. 41).

Because Benin had a spiritual tie to Ife, it was the custom when an oba died, according to oral tradition, that his head was sent to Ife for burial. In return, Ife metalsmiths made a brass cast of the head for the Edo palace shrine. Late in the fourteenth century, oral tradition continues, the oni of Ife sent a caster to Benin so that the Edo could learn to produce sculpture similar to that sent from Ife.

Although in oral tradition there is an artistic tie between Ife and Benin, the art that survives cannot be definitely linked. In contrast with the naturalistically sculptured heads of Ife, the heads from Benin depict the human face in a more stylized manner.

According to oral tradition, during the Ogiso dynasty rulers placed terra-cotta heads on their paternal ancestral altars just as contemporary obas do. About sixty terra-cotta sculptures in varying sizes and styles exist today, some of modern vintage (fig. 42). Some have the heavily outlined, almond-shaped eyes, broad nose, high coral-beaded collar, and tiered coiffure characteristic of the brass heads, and approximately half have a hole in the top (the purpose of the hole is unknown). Elephant tusks, a traditional symbol of longevity, are still inserted in the metal heads (see fig. 41). Some of the carved tusks are as long as six feet.

By the fifteenth century, the Edo were using the lost-wax method to cast in brass. The Edo associated brass, which resists rust, with the permanence and continuity of kingship. The metal's reddish patina and shiny surface, likened to sacrificial blood, augmented its linkage with power and the spirit world.

The brass heads from the earliest period have thin walls. Difficult to cast, the thin-walled sculptures used less of the limited supply of metal. Later, when European traders supplied ample metal, casters began to use the simpler technique of making sculptures with thicker walls. Some of the brass heads from the late period, after the mid-seventeenth century, weigh as much as sixty pounds.

The early brass heads, probably cast in the fifteenth century, are less elaborate than later works. Regalia is secondary and ornamental;

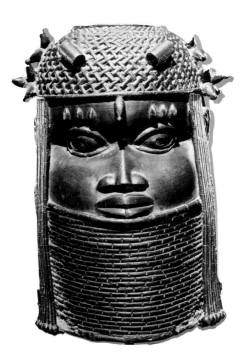

Fig. 44. Brass commemorative head, Benin, Nigeria. Royal commemorative heads of the mid-seventeenth century and later are heavy, thick-walled castings. The oba is depicted wearing a crown and a collar made from coral beads.

In the National Museum of African Art (85-19-16). Gift of Joseph H. Hirshhorn to the Smithsonian Institution. Height: 33 cm (13 in.).

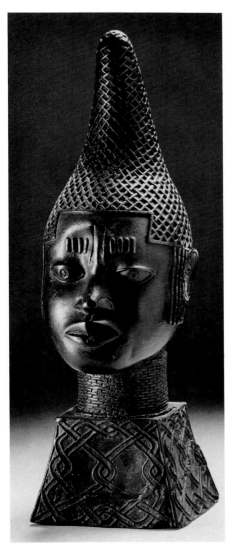

Fig. 45. Brass commemorative queen mother head, Benin, Nigeria. Commemorative brass heads for the queen mother depict her wearing a beaded crown over a distinctive elongated hairstyle.

In the National Museum, Nigeria. Height: 51 cm (20 in.).
Photograph by Dirk Bakker

a beaded collar, tucked under the chin, provides textural contrast to a smooth jawline. Instead of wearing a crown, the coiffure is simply styled in tiers. Some of these early sculptures may have been trophy heads commemorating victorious campaigns. Their hairstyles and supraorbital tribal marks may indicate male foreigners (neighboring peoples who were not Edo) (fig. 43).

The sculptures of the mid-seventeenth century depict the oba wearing a more prominent collar that rises to the lips (fig. 44). The simple coiffure has been covered with a beaded crown, fringed at the sides by representations of strands of beads and plaits of braided hair. These later sculptures, with the human face partially concealed by regalia, suggest that the symbolism of the office took precedence over the individuality of the ruler.

Sculptures representing the queen mother are said to have originated in the early sixteenth century when Oba Esigie commemorated his mother, Idia, who had aided in his successful reign. Elegant and regal, a queen mother head is characterized by a long conical headdress and a high coral collar (fig. 45). The heads were kept in queen mother shrines within the palace compound.

Coral and Ivory

Besides brass, coral, believed to have magical powers, was one of the king's prerogatives. Since it is not found in West African waters, coral from the Indian Ocean had to be imported to the kingdom of Benin.

Ivory, too, was precious, its whiteness symbolizing purity and peace. The oba received one tusk from every elephant killed in the kingdom. Ivory was abundantly available in Benin and, along with pepper and slaves, attracted traders carrying the fine cloth and metals that the Edo cherished.

At his public appearances once or twice a year, the oba, adorned with a crown, necklaces, and garments of coral beads, made a

Fig. 46. Oba Akenzua II at a public ceremony, Benin, Nigeria. The oba wears a crown, a collar, a gown, and necklaces made from coral beads. The whiteness of the elaborately carved ivory bracelets and waist pendants, as well as the ivory gong he carries, symbolize the oba's ritual purity.

Photograph by William Fagg, 1958

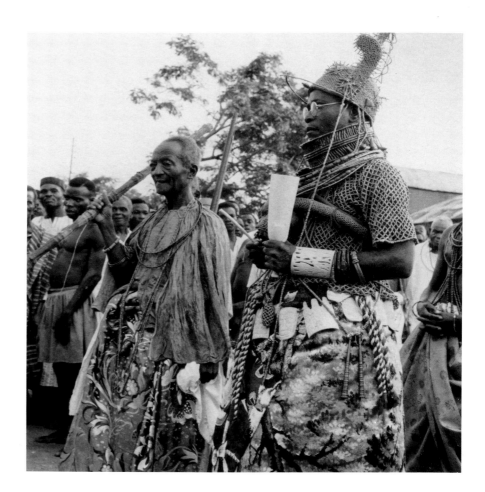

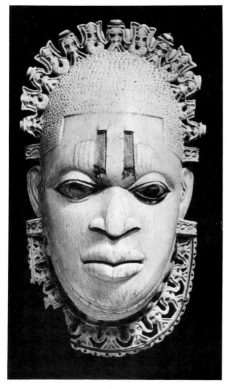

Fig. 47. Ivory mask, Benin, Nigeria. Ivory masks were worn at the hip or as pectoral ornaments by the oba as part of the ceremonial regalia. On this mask, which may represent the queen mother, Portuguese faces surmount the head and appear in the necklace. Because the Portuguese came from overseas, the faces on the mask may refer by association to Olokun, god of the sea and the source of Edo power and wealth. The pupils of the eyes and the grooves in the forehead were probably once inlaid with iron.

In the Metropolitan Museum of Art, The Michael C. Rockefeller Memorial Collection (1978.412.323). Gift of Nelson A. Rockefeller. Height: 23.8 cm (9.4 in.). Photograph by Lee Boltin

majestic figure (fig. 46). He wore delicately carved ivory bracelets, and ivory pendant masks lay on his hips against a red coral ceremonial gown. Several of the ivory pendant hip masks survive; some, said to represent the queen mother, have faces framed by rows of miniature Portuguese heads (fig. 47). The Portuguese heads are a symbolic reference to the overseas source of the kingdom's trading wealth and, by association, to Olokun, Benin's god of the sea.

A Great Benin Oba

Ewuare was one of Benin's greatest rulers. This fifteenth-century king is said to have originated the annual ceremonies in which protection and purification were sought for the kingdom and to have designed the coral regalia worn by the oba. As the first of the warrior-kings, he increased the nation's wealth by subduing a wide circle of neighboring villages and extracting tributes of food, livestock, and slaves. And he created a grand design for the new city of Benin, with broad streets and a separate palace enclave (fig. 48).

European travelers spoke of the city and its court life with admiration. Olfert Dapper, a Dutch trader, published a collection of reports about Africa in 1668. He used eyewitness accounts from Dutch merchants about the Benin court. "The king's court," he wrote, "is certainly as large as the town of Haarlem [in Holland] and is entirely surrounded by a special wall. . . . It is divided into many magnificent palaces, houses, and apartments of the courtiers. Fine

The Art of West African Kingdoms

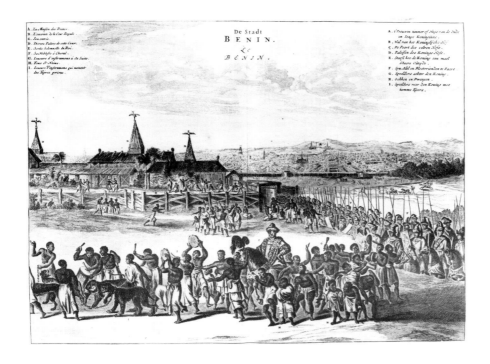

Fig. 48. Benin City and royal palace, seventeenth century, Benin, Nigeria. By the seventeenth century, the capital of Benin was a lively, well-organized city with broad streets. In the palace compound, the turreted roofs of the buildings were surmounted by sculptures of birds with spread wings.

Illustration published in Description de l'Afrique *by Olfert Dapper, 1686 edition.*

galleries, about as large as those on the Exchange at Amsterdam, are supported by wooden pillars, from top to bottom covered with cast copper on which are engraved [*sic*] the pictures of their war exploits and battles, and they are kept very clean."

Brass Plaques

The metal plaques that Dapper mentions are believed to have been cast between the early sixteenth and mid-seventeenth centuries. Long before the British entered Benin City in the late nineteenth century, the plaques had been removed and stored. They served as remembrances of Benin's past, providing illustrations for Benin's oral historians.

More than nine hundred of the plaques with figures in high relief are known today, most of them showing kings, chiefs, warriors, and courtiers in ritual stances. A plaque from the sixteenth century portrays a chief wearing a tunic, collar, and crown of coral (fig. 49). A leopard pelt hangs from his belt, and he holds a shield and a spear, emblems of his martial capabilities. He is flanked by attendants, who carry his ceremonial sword and blow horns and sound gongs to announce his arrival. Portuguese advisers, identified by their long, straight hair, beards, helmets, and European garb, flank the warrior in the upper corners of the panel. As with most of the plaques, the background pattern of this one consists of a four-petaled image of the leaf of a river plant, another symbol of Olokun.

Since the reinstallation of the oba in 1914, the Edo people have rebuilt the palace on a far more modest scale. Along with a shortening of the ritual cycle, the creation of royal ceremonial objects has sharply diminished. But artisans continue to work in the traditional styles, making sculptures and other objects for the royal court and for export.

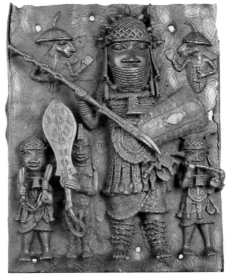

Fig. 49. Brass plaque, Benin, Nigeria. The prestige and power of a chief is emphasized in this brass plaque, dated between the sixteenth and seventeen centuries. Centrally located, he wears elaborate regalia and holds weapons. He is surrounded by smaller images of attendants and advisers, two of them Portuguese.

In the National Museum of African Art (82-5-3). Height: 46 cm (18.1 in.); width: 35 cm (13.8 in.).
Photograph by Ken Heinen

The Kingdom of Benin

Glossary

Anthropology. The study of human beings in relation to their origin, physical characteristics, social relations, and culture.

Archaeology. The scientific study of remains or artifacts of past human life and activities.

Asantehene. The highest chief of the Asante people.

Baldric. An often-decorated belt that is worn over one shoulder, usually to support a sword.

Berbers. A Caucasoid people of northwestern Africa.

Brass. An alloy of copper and zinc with traces of other metals.

Bronze. An alloy of copper and tin.

Calabash. A gourd that when dried has a hard shell. It is often decorated and used as a vessel. Designs carved into pieces of calabash shells are stamped onto plain cloth to make the *adinkra* of the Asante.

City-state. An autonomous state consisting of a city and its surrounding territory.

Coiffure. A style or manner of arranging the hair.

Coral. The horny skeletal deposit produced by certain types of marine life. Coral is often polished and used to make jewelry.

Cowrie shells. Found in warm seas, these shells often have glossy and brightly colored surfaces. Small white shells found in the Indian Ocean were once used as currency in African trade; they were considered a symbol of wealth and status when fashioned into jewelry.

Cult. A system of religious beliefs and rituals and its body of adherents.

Desert. An arid, barren land.

Diviner. One who seeks to foresee or foretell future events or discover hidden knowledge, usually by the interpretation of omens or by the aid of supernatural powers.

Finial. A crowning ornament or decorative detail, such as a staff top.

Griot. A professional musician, historian, bard, and storyteller in the Western Sudan region. The griot's traditional stories and songs praise the deserving and mock those who are unjust or less deserving.

Guild. Association formed for mutual aid and instruction and for the furtherance of professional interests.

Herbalist. One who practices healing by the use of herbs.

Iconography. The imagery or symbolism of a work of art.

Initiation. To induct an individual into a particular cult or association by special rites and ceremonies. Initiation into many African associations marks the transition from childhood to adulthood.

Ivory. The hard, creamy-white substance that composes the tusks of elephants and some other mammals.

Lineage. A group of individuals who are descended from the same ancestor. Individuals trace their descent to a common progenitor through either their paternal line or their maternal line, according to whichever principle is adopted by their culture.

Lost-wax casting. A method for casting metal objects. A core of clay is modeled to a size slightly smaller than that desired for the finished work. The core is covered with a layer of wax, which is then carefully detailed. The wax-covered core is enclosed in a clay investment, but a hole is left in the outer layer as a channel to the core. As the entire mold is heated, the melted wax is drained from the mold through the hole. Molten metal is poured into the hardened mold. When the metal has cooled and hardened, the baked clay is broken away to reveal the cast object.

Mace. An ornamental staff carried as a symbol of authority and status, or a club used as a weapon.

Malaria. A serious, chronic infection in humans that is characterized by periodic episodes of chills, fever, anemia, enlargement of the spleen, and often fatal complications. It is caused by parasites transmitted by anopheline mosquitoes.

Mihrab. A niche or small room in a mosque that indicates the direction of Mecca. Muslims face Mecca when they pray.

Minaret. The tower of a mosque from which worshipers are summoned to prayer.

Oba. The ruler of the kingdom of Benin.

Oni. The ruler of the Yoruba kingdom of Ife.

Oral history. The unwritten record of history that is conveyed verbally from one generation to the next.

Palanquin. A conveyance for one person that is carried on the shoulders of men by means of poles.

Patina. A pleasing finish or coloration due to age, use, or exposure to the elements.

Potsherd. A pottery fragment.

Radiocarbon dating. A scientific procedure for estimating the age of an object by measuring the amount of radioactive carbon present. Radioactive carbon is present in all organic materials and is believed to deteriorate at a constant rate after the organic material dies.

Rain forest. A tropical woodland receiving at least one hundred inches of rainfall annually. Tall trees form a canopy over the dense underbrush.

Savanna. A tropical or subtropical grassland with scattered trees.

Scarification. Permanent patterned marks on the body made by incisions on the skin.

Scimitar. A saber made with a curved blade.

Sculpture. A three-dimensional work of art produced by carving, modeling, or casting of a plastic or hard material.

Sleeping sickness. A disease, transmitted by the tsetse fly, marked by fever, protracted lethargy, tremors, and loss of weight.

Symbol. Something that represents or suggests something else. A visible sign of something invisible.

Terra-cotta. Clay that has been fired to a stonelike consistency.

Template. A pattern or mold used as a guide to the form of a piece being made.

Thermoluminescence dating. A scientific procedure for determining the age of terra-cotta objects. Traces of naturally occurring radioactive elements in a terra-cotta object release small amounts of radiation. This radiation is captured by clay crystals. The firing process used to harden a terra-cotta object releases any radiation previously in the clay, so the radiation present in the clay crystals of an object dates from the time shortly after firing. In thermoluminescence testing, clay samples from an object are heated. The radiation is released as light, which is measured. The longer the period for radiation to build up in the clay crystals, the greater the light energy released when the crystals are heated.

Tsetse fly. An insect that transmits the disease referred to as sleeping sickness.

Bibliography

General/Kingdoms of the Western Sudan

Atmore, Anthony, and Gillian Stacey. *Black Kingdoms, Black Peoples: The West African Heritage.* New York: Putnam, 1979.
A well-written book for general readers with an excellent selection of color photographs. Highly recommended.

Boahen, A. Adu. *Topics in West African History.* London: Longman, 1966.
An African historian's perspective on West African history for secondary-level readers. The author summarizes the history of the Sudanic and forest kingdoms in sixteen short chapters. Not illustrated.

Boahen, A. Adu, and others. *The Horizon History of Africa.* Edited by Alvin M. Josephy. New York: American Heritage, 1971.
This comprehensive, exceptionally well-illustrated history of Africa features essays by twelve scholars. Also includes folklore and excerpts from early writings. See especially the chapter on West African kingdoms.

Cable, Mary. *The African Kings.* Chicago: Stonehenge, 1983.
A lushly illustrated book that tells stories of African kings with historical accuracy and insight. Includes chapters on "The Forest Kings" (Nok and the Yoruba kingdoms), "Osei Bonsu" (Asante), and "The Oba of Benin."

Crowder, Michael, and Guda Abdullahi. *A History of West Africa: A.D. 1000 to the Present.* London: Longman, 1979.
Traces the history of the major West African kingdoms. A readable and clear format. Highly recommended.

Davidson, Basil. *The African Past: Chronicles from Antiquity to Modern Times.* Boston: Little, Brown, 1964.
A collection of translated writings about Africa by travelers and traders, including the observations of Muslim and European chroniclers of West Africa.

———. *Africa: History of a Continent.* New York: Macmillan, 1966.
An over-size volume with many historical and contemporary photographs and maps, the book covers African history from earliest times through the period of independence.

———. *African Kingdoms.* New York: Time-Life Books, 1966.
A lively, well-illustrated book for general readers that recounts the history of the kingdoms. The chapter "Merchant Empires" discusses Ghana, Mali, and Songhai, and "Forest Kingdoms" looks mainly at Benin and briefly at Asante.

———. *The Story of Africa.* London: Mitchell Beazley, 1984.
This book accompanied a British television series about Africa narrated by the author. Five chapters discuss the history of the kingdoms of West Africa, including the gold trade, the impact of Islam, and the trading relationship between Africa and Europe.

Encyclopaedia Britannica: Macropaedia. 15th ed., under "African Peoples, Art of."
This thorough article, illustrated with color photographs, includes an excellent survey of the art of the West African cultures. It is a useful starting point for a study of African arts and cultures.

Gann, Lewis H., and Peter Duignan. *Africa and the World: An Introduction to the History of Sub-Saharan Africa from Antiquity to 1840.* San Francisco: Chandler Publishing, 1972.
Seeking to place pre-colonial African history in the wider context of world events, the authors have written an up-to-date, well-researched text. They provide a judicious selection of historical maps. The chapter "Some Early West and Central African Empires" explains that the African kingdoms, far from being isolated, had long and enduring contact with the Mediterranean and Islamic worlds.

Garlake, Peter S. *The Kingdoms of Africa.* Oxford: Elsevier-Phaidon, 1978.
An easy-to-read introduction to the African kingdoms with many color photographs and illustrations. Includes a chapter on the kingdoms of West Africa and a photographic essay about the sculpture of Ife and Benin.

Gillon, Werner. *A Short History of African Art.* New York: Facts on File, 1984.
Includes chapters that explore the artistic heritage of the early savanna and forest kingdoms. Nicely illustrated.

Kwamena-Poh, Michael, Michael Tidy, John Tosh, and Richard Waller. *African History in Maps.* London: Longman, 1983.
Maps and full-page explanations relate much historical information. Of interest are "West Africa to about 1600," "West African States, 1600 to 1800," and "West African States and Economic Change in the 19th Century."

McEvedy, Colin. *Atlas of African History.* New York: Facts on File, 1980.
Presents concise maps and explanations of kingdoms, movements of people, trade routes, language groupings, and colonial possessions. Maps are in chronological sequence.

Mair, Lucy Philip. *African Kingdoms.* Oxford: Clarendon Press, 1977.
An anthropological approach to the study of African kingdoms, considering such topics as courts and capitals, royalty and ritual, resources, internal organization, and succession contests. An advanced resource for understanding African kingdoms.

Murray, Jocelyn, ed. *Cultural Atlas of Africa.* New York: Facts on File, 1981.
A general introduction to the geography and cultural background of Africa and a country-by-country survey of the continent. Numerous maps, illustrations, and a thorough index make this an excellent reference guide.

Oliver, Roland, and Michael Crowder, eds. *Cambridge Encyclopedia of Africa.* New York: Cambridge University Press, 1981.
A major reference tool, this encyclopedia has an extensively illustrated, authoritative chapter titled "The African Past." See especially passages in the section "Before European Colonization."

Prussin, Labelle. *Hatumere: Islamic Design in West Africa.* Berkeley: University of California Press, 1986.
This scholarly text deals primarily with West African architecture. Includes an excellent section on the architecture of the kingdoms of the Western Sudan.

Stride, G. T., and Caroline Ifeka. *Peoples and Empires of West Africa: West Africa in History, 1000-1800.* New York: Africana Publishing, 1971.
Includes brief chapters on Ghana, Mali, and Songhai.

Willett, Frank. *African Art: An Introduction.* New York: Thames and Hudson, 1971, reprinted 1985.
The author brings experience as an archaeologist and art historian to this general survey of African arts. He writes with authority on ancient sculpture.

The Kingdom of Asante

Cole, Herbert M., and Doran H. Ross. *The Arts of Ghana.* Los Angeles: Museum of Cultural History, University of California, 1977.
This exhibition catalogue explores many of the Ghanaian arts, not only those of the Asante. It covers sculpture (including goldweights), textiles, architecture, household objects, musical instruments, and festivals.

Kyerematen, A. A. Y. *Panoply of Ghana: Ornamental Art in Ghanaian Tradition and Culture.* New York: Praeger, 1964.
This charming book is of particular interest because it is written by an Asante cultural historian. He explains how the objects of regalia and kingship relate to Asante history. Out of print and difficult to find.

McLeod, M. D. *The Asante.* London: British Museum Publications, 1981.
Some of the finest Asante regalia and goldwork are in the collection of the British Museum. This exhibition catalogue provides background on the Asante and their art.

The Kingdom of Dahomey

Adams, Monni. "Fon Appliquéd Cloths." *African Arts* 13 (February 1980): 28-41 and 87-88.
A scholarly discussion of the evolution of this art form.

Argyle, William John. *The Fon of Dahomey: A History and Ethnography of the Old Kingdom.* Oxford: Clarendon Press, 1966.
A scholarly study of the kingdom of Dahomey in the eighteenth and nineteenth centuries that treats all aspects of its history: political, economic, social, and religious. An advanced text that is not illustrated.

Herskovits, Melville J. *Dahomey: An Ancient West African Kingdom.* 2 vols. New York: J. J. Augustin, 1938.
Regarded as the seminal work on the kingdom of Dahomey, the book, now out of print, is a scholarly study with an anthropological focus. Of particular interest are the chapters on the visual arts.

The Yoruba Kingdoms

Crowder, Michael, and Guda Abdullahi. *Nigeria: An Introduction to Its History.* London: Longman, 1979.
Exceptionally well-illustrated account of Nigeria's history. Includes chapters on the Yoruba kingdoms and Benin.

Eyo, Ekpo. *Treasures of Ancient Nigeria.* New York: Knopf, 1980.
This catalogue accompanied a stunning exhibition of Nigerian art. It presents a knowledgeable overview of the rich artistic heritage of Nigeria, discussing and illustrating art from Nok, Ife, Igbo-Ukwu, and Benin.

Fagg, William, and John Pemberton. *Yoruba Sculpture of West Africa.* Edited by Bryce Holcombe. New York: Knopf, 1982.
A catalogue that illustrates and documents the impressive range and variety of Yoruba sculpture. Introductory essays are definitive expositions of the present knowledge concerning Yoruba art.

Shaw, Thurstan. *Nigeria: Its Archaeology and Early History.* London: Thames and Hudson, 1978.
Draws together the latest information about the early cultures of Nigeria. Written from an archaeological perspective, it focuses on the excavations and finds. Two chapters discuss Ife and Benin. Amply illustrated.

The Kingdom of Benin

Ben-Amos, Paula. *The Art of Benin.* New York: Thames and Hudson, 1980.
A highly readable, thoroughly documented book that discusses the art of Benin in its historical, religious, and social context. Well illustrated.

Crowder, Michael, and Guda Abdullahi. *Nigeria: An Introduction to Its History.* London: Longman, 1979.
See annotation under "The Yoruba Kingdoms."

Eyo, Ekpo. *Treasures of Ancient Nigeria.* New York: Knopf, 1980.
See annotation under "The Yoruba Kingdoms."

Curriculum Materials

Africa. Lands and People, vol. 1. Danbury, Conn.: Grolier, 1985.
The countries of Africa are explored in this up-to-date resource book about the African continent. The chapters on Mali, Ghana, Benin, and Nigeria discuss ancient history and modern developments. Many color photographs and maps.

African Art and Culture: Course in Ethnic Studies. Newton, Mass.: Education Development Center, 1975.
Several African cultures form the basis of this two-volume art curriculum: Asante (Ghana); Yoruba (Nigeria); Dogon (Mali); and Kuba (Zaire). Themes include aesthetics, architecture, and the trans-Atlantic tradition. Volume 1 contains discussion units. Volume 2 provides sixteen experiences for children in grades K-6.

"The Asante World." *Faces* 1 (no. 4, 1985).
Children can read about the Asante culture and arts in this special issue of the magazine *Faces*. Includes Asante proverbs, games, and a folktale. For copies, write to Cobblestone Publishing, Inc., 20 Grove Street, Peterborough, N.H. 03458.

Chijioke, F. A. *Ancient Africa.* New York: Africana Publishing, 1971.
Short chapters written for the primary-level reader explain the kingdoms of Ghana, Mali, Songhai, Benin, and Asante, as well as other early African kingdoms. Includes color illustrations, maps, and study questions.

Chu, Daniel, and Eliot Skinner. *A Glorious Age in Africa: The Story of Three Great African Empires.* Garden City, New York: Doubleday, 1965.
Upper-primary readers will find this an absorbing, readable history of the kingdoms of Ghana, Mali, and Songhai. Nicely illustrated with drawings and maps.

Mark, Cynthia. *African Arts.* Chicago: Field Museum of Natural History, Department of Education, 1977.
This booklet includes a section on *adinkra* cloth patterns of the Asante and appliqué cloth designs of the Fon. For primary students.

Robinson, David, and Douglas Smith. *Audiovisual Guide to Sources of the African Past.* New York: Africana Publishing, 1979.
Supplements the authors' book *Sources of the African Past* (New York: Africana Publishing, 1979). Five history units focus on major African historical figures. Unit 5 discusses "Osei Bonsu and the Political Economy of the Asante Empire." Slides, tapes, and booklet. For upper-elementary to junior high school students.